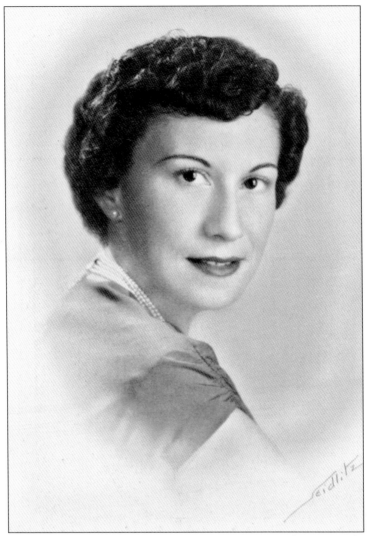

Yvonne Carey (Butler) moved to Port Royal in 1930, commencing her 75-year love affair with the small town. She valued the close-knit community and vowed to give back as much as the town had given her. Yvonne fondly remembered square dances at the school and neighborhood crab and shrimp boils. She recalled taking her mother's Jersey cow to the railroad tracks, where the grass was good and tall, every day before school. She would also fish under the pilings at the docks with a big safety pin and a worm. Another memory was running to the little jailhouse, resembling an outhouse, on Sunday morning to see who had misbehaved with the booze the night before. Yvonne married Max Butler in 1948, and she insisted they return to her hometown after he fulfilled his commitment with the Marine Corps. They did in 1962. Yvonne accomplished her goal of giving back to Port Royal, indeed. She served on the town council for 20 years and was an active member of the Port Royal Methodist Church. Her concern for the citizens of Port Royal is esteemed as one of her most endearing attributes. (The family of Yvonne Carey Butler.)

ON THE COVER: Striker Billy North and David Chaplin fill baskets with shrimp on the SS *Chaplin*. It was a good day—the nets dropped 2,560 pounds on the deck, filling 32 bins. The shrimp trawler was named after the owner's father, Saxby Stowe Chaplin Sr. (Bobby and Martha Chaplin.)

IMAGES of America
PORT ROYAL

Wendy Nilsen Pollitzer

Copyright © 2006 by Wendy Nilsen Pollitzer
ISBN 0-7385-4353-5

Published by Arcadia Publishing
Charleston SC, Chicago IL, Portsmouth NH, San Francisco CA

Printed in the United States of America

Library of Congress Catalog Card Number: 2006930541

For all general information contact Arcadia Publishing at:
Telephone 843-853-2070
Fax 843-853-0044
E-mail sales@arcadiapublishing.com
For customer service and orders:
Toll-Free 1-888-313-2665

Visit us on the Internet at www.arcadiapublishing.com

To my mom, Shirley Nilsen, whose guidance, love, and reassurance give me strength every day.

Contents

Acknowledgments		6
Introduction		7
1.	Port Royal, the Town	9
2.	A Marine and Port Affair	61
3.	Shrimpin', Crabbin', and Fishin'	85
4.	A Revitalization	105

Acknowledgments

It is difficult to compile a book of this nature alone. Many people in the community assisted by sharing their photographs, their memories, and their valuable information. One organization in particular was quite generous with their collection. The Historic Port Royal Foundation (HPRF) organized a campaign several years ago to gather material pertaining to the history of Port Royal from longtime residents. I was fortunate to partner with the foundation for this project, and I would like to sincerely thank its past and present members and officers for preserving Port Royal's history. In particular, I wish to acknowledge Mike Jones, Harold Guerry, Terri Lee, and Leila Stevens for all of their help.

Gerhard Spieler's *A Brief History of the Town of Port Royal* and Martha Ann Tyree Moussatos's *No Fayrer or Fytter Place* provided significant information on the history of Port Royal, as did *A History of Beaufort County* by Dr. Lawrence S. Rowland and the *History of South Carolina State Ports Authority* by Anne Moise. Professional counsel from historian Steve Wise was particularly useful, and photography by Ned Brown added an artistic flavor. Grace Cordial, curator of the South Carolina Room at the Beaufort County Library, was pleasantly accommodating and informative. You have all earned my immeasurable gratitude.

Several people shared precious images and vivid accounts of their youth. Thank you for opening your homes and bestowing your knowledge and wisdom. I thoroughly enjoyed each of your visits. I wish to thank Betty Abraham, Colden Battey, Kent Bishop, Linda Bridges, the family of Yvonne Butler, Catherine Brooks, Bobby and Martha Chaplin, Jack and Sally Chaplin, Bobby Cooler, Pete Cotter, Allen Davis, Chuck Ferguson, Doris and Sammy Gray, Lecian Henry, Linda Herring, Brantley Hodges, Ann Ritter Holmes, Ben Jackson, Mary Jack Jones, Kay Keeler, Kathleen Knisley, Richard Moody, Martha Ann Moussatos, George O'Kelley, Ogden Lazenby, Tanya Payne, Tony Pesavento, Lottie and Wally Phinney, Stratty Pollitzer, Terry Poore, Faye and Ned Rahn, Margaret Rodgers, Bill Scheper, Willie Scheper, Cynthia Smalls, Zach Tedder, Sandie Tucker, Mickey Vaigneur, Stan Waskiewicz, Alice and Charlie Wilson, Lewis Wright, and Bill Youmans. I'd also like to thank the following businesses and organizations: the *Beaufort Gazette*, the Beaufort County Library, the faculty and staff at E. C. Montessori School, Murr's Printing, the Rhett Gallery, Port Royal Elementary, the South Carolina Historical Society, the South Carolina State Ports Authority (SPA), the Town of Port Royal, and Latrice Jenkins and Cynthia Searles at Walgreen's on Ladies Island.

Thank you, Richard, my devoted husband, for your encouragement. I love you dearly and appreciate your help with Abbie and Julia. I missed your company and playtime with the girls during my frequent absences. Thanks also to my mom and dad, Shirley and Stewart Nilsen, for your continued love and support; to Anne and Ricky for your insightful conversations; to my dear friend Wendi for your daily dose of humor; and to my editors, Adam Ferrell and Kendra Allen, and publisher, Lauren Bobier, for your expert guidance. Lastly, thank you to all who are earnestly trying to safeguard historic homes in Port Royal through your restorations and political involvement.

INTRODUCTION

The Town of Port Royal was incorporated in 1874; the history of the Port Royal area, however, dates back to 1562, when Capt. Jean Ribaut, a French Huguenot, led an expedition with two vessels from Havre de Grâce, France, to prey on Spanish treasure fleets returning to Spain from Central and South America. Ribaut discovered a large harbor with marshes, rivers, and inlets surrounding its entrance. He named the area Port Royal and the settlement Charlesfort. Ribaut wrote that he had found "no faurer or fytter place . . . than Port Royal." The Spanish later destroyed Charlesfort to erase any claim the French had on the land and eventually established a permanent settlement in St. Augustine, Florida. In 1669, the English settled the region, colonized present-day Beaufort, and later established a permanent settlement at Albermarle Point in Charleston.

In 1727, the British built a fort they named Fort Frederick to protect South Carolina against French, Indian, and Spanish threats. By 1758, Fort Lyttleton was built at Spanish Point and Fort Frederick abandoned. Fort Frederick and the surrounding land was absorbed into Old Fort Plantation, owned by John Joyner Smith. When Union troops captured Port Royal, Smith's plantation became headquarters to the first regiment of freed slaves recruited for Federal service. The site was renamed Camp Saxton. After the Civil War, the land was sold at a direct tax sale to the U.S. government. The Port Royal Railroad Company petitioned the State of South Carolina to construct a railroad from Augusta, Georgia, to Port Royal Island, South Carolina, and also build a city at its terminus. Investors began speculating land to become the town of Port Royal. As late as 1867, Land's End on St. Helena Island was expected to be the terminal of the railroad.

Port Royal Railroad Company ultimately chose acreage surrounding the Old Fort Plantation for the site of its terminus. In 1869, Stephen Caldwell Millett began construction on the railroad that spanned all of Port Royal Island, from the Coosaw River to the Battery River. It was completed in 1874, the same year a charter was issued for the town of Port Royal. The town was laid out with wide streets, 25-by-100-foot lots, and 200-by-500-foot blocks, with commercial and industrial development in mind. Port Royal grew quickly, boasting a cotton compress, reputed to be the largest in the world, numerous train elevators and warehouses, and a thriving port. Vessels loaded coal, phosphate, and lumber brought in by rail. The phosphate industry in the Port Royal area alone employed 2,500 to 3,000 people and shipped out more than Charleston and Savannah combined.

In 1876, a coaling station and naval storehouse at neighboring Parris Island was set up, followed by the construction of the largest wooden dry dock on the East Coast. The U.S. Naval Station at Port Royal welcomed great battleships. In fact, the USS *Maine* was stocked with provisions from the Scheper Store in Port Royal before departing for Cuba on what became its final voyage. The loss of the battleship in the harbor at Havana triggered the Spanish-American War.

During the 1800s, many homes were built by prospering merchants. The town enjoyed mercantile establishments, grocery stores, drugstores, a hotel, a bakery, a blacksmith, and 17 bars. The town even supported its own newspaper, the *Palmetto Post*.

In August 1893, a great hurricane struck the area. Railroad tracks were washed out, and much of the machinery of the phosphate industry was destroyed. The catastrophe was followed by political conflict of Upstate and Lowcountry interests. Gov. "Pitchfork" Ben Tillman raised the state tax on each ton of phosphate from $1 to $2. Subsequently merchants obtained phosphate in Florida at a cheaper price. The two phosphate mines in Port Royal—Baldwin and Wilson—eventually closed. Another calamity occurred when a visiting schooner brought in a deadly yellow fever epidemic, causing a large loss of life. As a final blow, the secretary of the navy ordered that the Port Royal Navy Yard be moved to Charleston in 1902. Business with the Port Royal Railroad began to decline as railroad interests moved to Augusta. The cotton compress and the train elevators were removed; discriminatory tariff rates diverted railroad business to Charleston and Savannah; and the advent of the automobile and trucking took away much of what was left of the railroad business in Port Royal.

Small industry saved the town from total economic and social demise. In 1922, Capt. Charles Vecchio brought commercial shrimping to Port Royal. Local entrepreneurs invested in boats, and large-scale shrimping soon followed. In 1937, Blue Channel Corporation, packers of Atlantic Seafood, moved into town, providing good jobs and opportunity to the area. The Parris Island Marine Corps Recruit Depot expanded during World War II, also providing civilian jobs to residents of Port Royal and a small but stable economy for the town. In 1958, the Port of Port Royal was dedicated, which created hope that Port Royal would once again enjoy great wealth.

In October 1997, the Town of Port Royal adopted the Traditional Town Overlay District. It put restrictions on material, size, and placement of new structures on Paris Avenue and other streets in the heart of town. Though it upset many residents, the ordinance was intended to control growth, create pedestrian-friendly streets, encourage newcomers, and generally beautify the town, and that it did.

Today Port Royal is in the midst of making significant history. In 2004, Gov. Mark Sanford signed legislation to sell the Port of Port Royal, owned by the state. The valuable waterfront acreage is scheduled to be sold to developers by December 2006, which will put the property back on the town's tax rolls and allow the village to stand tall and distinguished once more.

One
PORT ROYAL, THE TOWN

Port Royal is one of the oldest geographic terms used in South Carolina. There is a Port Royal Plantation on Hilton Head, Port Royal Island, Port Royal Sound, and even a proposed town of Port Royal on St. Helena Island. There was also a Port Royal Post Office on Hilton Head, Port Royal County, Port Royal Street in Beaufort (Port Republic), Port Royal River (Beaufort River), the Port Royal Experiment, and the Port Royal Railroad Company. So where did the name come from? Capt. Jean Ribaut, a French Huguenot, was intent on founding a settlement where Protestants could escape persecution by Catholics in their homeland. After establishing French claim to the River May (St. Johns River), Ribaut sailed north and entered a large harbor that he named Port Royal. He erected a stone monument on a site he described as "one of the greatest and fayrest havens of the world." Ribaut returned to France and left behind 26 men. They built a fort and a house that served as a storehouse and barracks and called it Charlesfort. After a year, there was little hope that Ribaut would return, and with limited supplies, the men abandoned the outpost. Phillip II, King of Spain, ordered the destruction of Charlesfort and the stone monument, but neither the French nor the Spanish returned to claim Port Royal Island. There was, however, British and Scottish presence through the 17th century; but again, neither country established a permanent settlement. In 1721, after the British settled Charleston, their Independent Company of Foot built Fort Frederick to protect South Carolina against French, Native American, and Spanish threats. By 1800, John Joyner Smith owned Fort Frederick and the surrounding land, which was known as Old Fort Plantation. Shortly after Union occupation of Beaufort, most of the land on the southern tip of Port Royal Island, including this plantation, was sold at a direct tax sale. Acquisitions were made on behalf of the Port Royal Railroad Company by Stephen Caldwell Millett. The terminus was built, and by 1874, the Town of Port Royal was incorporated.

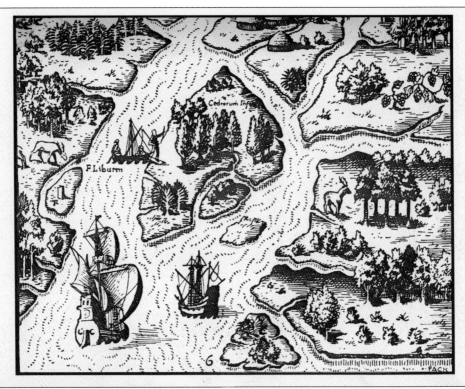

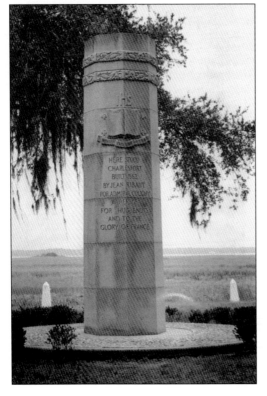

Jacques le Moyne accompanied the second expedition to the New World and painted two maps of the Port Royal area. The original paintings were lost when the Spanish destroyed Fort Caroline. Le Moyne escaped the massacre and returned to Europe, where he reproduced 42 of the lost paintings as best as he could. Those paintings too disappeared; fortunately Theodore de Bry had engraved all of le Moyne's paintings in Frankfort in 1591. One of de Bry's engravings is *Portus Regalus* (above), which shows French vessels in Port Royal Sound. (HPRF.)

In 1925, the U.S. Congress erected this monument on the site where Maj. George Osterhoust believed stood Charlesfort. Subsequent research indicated that he had actually excavated remains of a Spanish fort, Fort San Marcos. In 1979, Stanley South found a second Spanish fort, Fort San Felipe. Through archeological and documentary research, South, Chester DePratter, and James Legg determined that Fort San Felipe was built in the same location as Charlesfort only a few years after the French abandoned the site. (HPRF.)

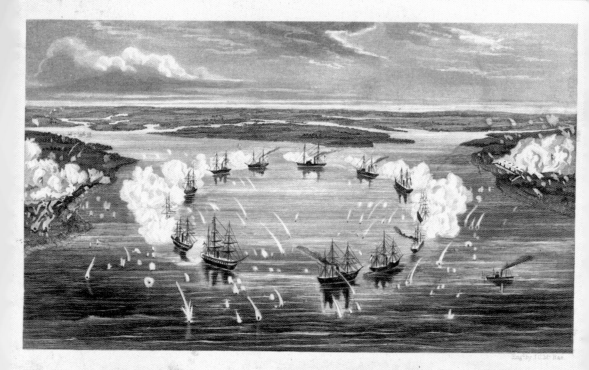

BOMBARDMENT OF PORT ROYAL.
Designed & Engraved Expressly for Abbott's Civil War.

The Battle of Port Royal Sound or "The Day of the Big Gun Shoot," as coined by freedmen of the Sea Islands, began on the morning of November 7, 1861. Union forces favored Port Royal Sound as the nucleus for an aquatic blockade of the South and used the deep harbor as a place to restock ships. While Union forces were amassing, Confederate troops countered by building Forts Beauregard and Walker in the summer of 1861, largely with slave labor. Union vessels formed an elliptical pattern in the sound, which allowed the boats to keep moving while attacking the stationary forts. Confederate forces were defeated, and Beaufort became the first Southern city to be occupied by Union troops. The established social order that endured for years in Beaufort and Port Royal disappeared.

When landowners evacuated en masse prior to the Battle of Port Royal Sound, slaves were given orders to stay on the plantations and plant provisioning crops for their own sustenance. John Joyner Smith owned a plantation on the site of the present-day Naval Hospital that became the location where freed slaves were recruited for Federal service. The plantation became known as Camp Saxton, headquarters for the 1st South Carolina Volunteers. On January 1, 1863, the Emancipation Proclamation was read under this tree at Camp Saxton.

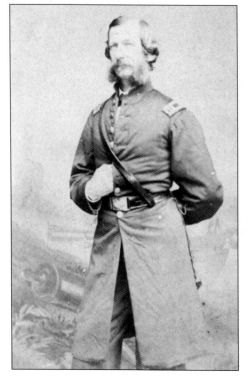

Thomas Wentworth Higginson was a captain in the 51st Massachusetts Volunteers. When the Union army occupied Port Royal, Higginson became the colonel of the 1st South Carolina Volunteers, the first regiment recruited from former slaves for Federal service. Higginson contributed to the preservation of Gullah spirituals by copying dialect verses and music he heard sung around the regiment's campfire. (Richard Moody.)

Zion Baptist Church was built in 1804. Located on what is now Fifteenth Street, the church was built for the slaves on Smith's plantation. After years of losing members, the congregation donated the church and the land to the Town of Port Royal. In 1987, the building was torn down, and the town sold the land. It was the oldest structure in Port Royal. (Martha Ann Tyree Moussatos.)

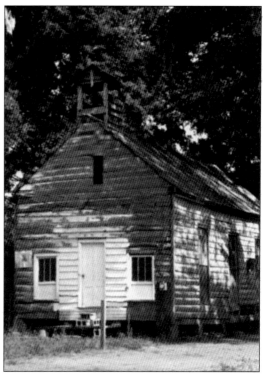

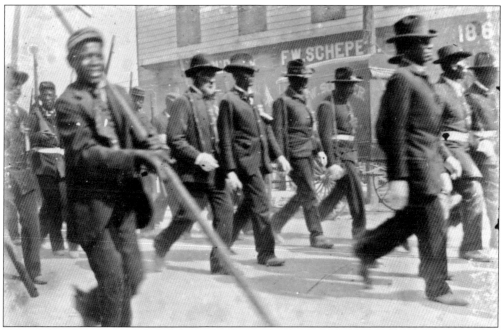

According to historian Lawrence S. Rowland, these men were members of the David Hunter Post of the Grand Army of the Republic. As veterans of the Union army, they marched in parades on Bay Street in Beaufort every Memorial Day. Unique to this picture is the presence of the Scheper Store on Bay Street, which burned in 1907. Both Scheper Stores in Beaufort and Port Royal were owned by the same man, F. W. Scheper. (HPRF.)

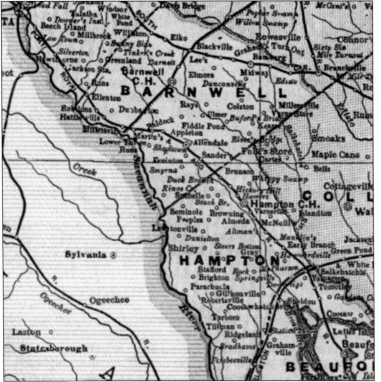

In 1857, the Port Royal Railroad Company (PRRC) was issued a charter from Port Royal to Augusta, crossing the Savannah River at Beech Island. The South Carolina General Assembly passed the act on the stipulation that directors could not call an organizational meeting until they had $250,000 in stock subscription commitments and $25,000 in cash deposited. Right-of-way acquisition was not difficult, and by the start of the Civil War, bed work was underway. (SC Historical Society.)

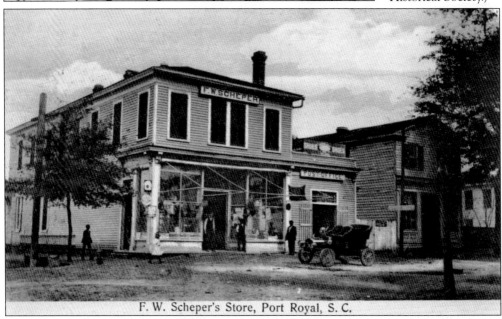

F. W. Scheper's Store, Port Royal, S. C.

In partnership with Jonathan D. Manett, Frederick W. Scheper established a mercantile store in Port Royal in 1868. The store burned in 1883, and in 1885, after buying out the Manett heirs, Scheper built a two-story, wood-framed structure in the Victorian commercial style on the corner of Eighth Street and Paris Avenue. This photograph was taken in 1908, when the store was managed by Scheper's son, Freddie. (HPRF.)

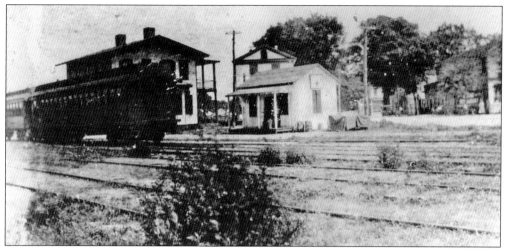

Construction of the railroad was suspended after the Union fleet captured Port Royal Sound. Boston capitalists reactivated the PRRC after Hilton Head and Charleston failed to secure the funds needed by the statutory deadline. Daniel Appleton and Royal Robbins purchased voting control of the bankrupt PRRC. Their agent was a Beaufort merchant, Stephen Caldwell Millett. A silent partner was William Appleton, a Boston banker and representative to the 37th Congress who happened to be a member of the House Ways and Means Committee. As the acting president, Millett purchased tracts of land ranging in size from 5 to 500 acres directly from the U.S. tax commissioners and private landowners for the construction of a rail terminus. Deeds were transferred to Daniel Appleton once the rail right-of-way was secured. Months of slowed construction and financial difficulties followed, but the final spike of the 110-mile track was nailed in February 1873. The Town of Port Royal became incorporated, and development around the rail terminal exploded. (Town of Port Royal.)

The Port Royal Railroad Company sold its operation to the Charleston and Western Carolina line in 1896. Irvin Magahee (right), an engineer for the C&WC, and an unidentified man sit on Engine 252 in Port Royal. (Doris and Sammy Gray.)

Samuel Henry Rodgers founded the *Palmetto Post* in 1882. Rodgers was editor and publisher of the Democratic weekly newspaper. The newspaper's headquarters were in Port Royal in the building commonly known as the Old Masonic Lodge. The *Palmetto Post* moved to Beaufort in 1906 and consolidated with the *Beaufort Gazette* in 1907. Rodgers was an active steward at Carteret Street Methodist Church, a member of the Port Royal Masonic Lodge and founder of the Beaufort County Democratic Club. He was elected clerk of court for Beaufort County in 1904 and served until his death in 1919. In 1985, Walter Rodgers Sr. published a book of S. H. Rodgers's poetry and titled it *The Palmetto Poet*. (Margaret Tedder Rodgers and HPRF.)

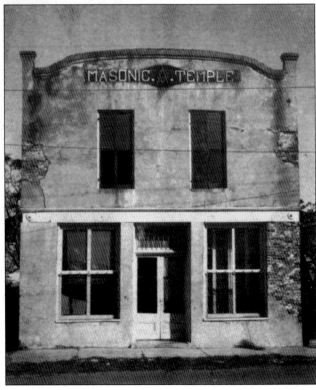

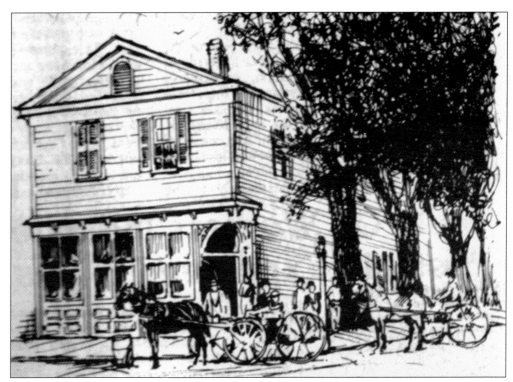

This building was originally constructed as a residence by the Appleton family in 1866. J. K. Attaway and Company later bought the building, sold "fancy groceries" on the first floor, and made apartments on the second floor. A few years later, it became Burckmyer's Store. In 1938, J. H. Kent purchased the building and leased it to his daughter and son-in-law, Doris and Elmo Metcalf. (HPRF.)

This house, located at 917 Ninth Street, was built by J. C. Mardenborough in the late 1880s and later sold to E. A. Scheper. In the early 1900s, Joseph Stickley purchased the house after coming to the area to profit from phosphate mining. He later became Port Royal's 11th mayor. The Stickley family remained owners until 1949. (Martha Ann Tyree Moussatos.)

The Union Church, also known as the Free Church, was built in 1878 on land donated by the Appleton family to a board of trustees committed to building a church where citizens of all denominations could worship. It was used by Presbyterians, Baptists, Methodists, and members of the Tabernacle Church. Congregations either worshipped on alternating Sundays or at different times on the same Sunday. (HPRF.)

Carpenter's Hall was erected in the mid-1880s. It served as a town hall, a school, a community center, and as the Ground Observer Corps during World War II. In the early 1940s, the Carpenter's Union purchased the building (left) and occupied it until 1962. It was located at the end of Paris Avenue, land now occupied by the SPA. The building was moved to its current location at 933 Paris Avenue in 1995 and completely renovated (right). (HPRF.)

Rebecca Schroder (seated) married the original F. W. Scheper in 1865, five years after he immigrated to Charleston from Germany. The couple lived at 906 Eighth Street in Port Royal. Beatrice Johns Scheper (standing) married their oldest son, Freddie. They lived next door at 904 Eighth Street, pictured below. The house, built in 1885, was torn down in June 2006. The neighboring house, however, still stands. A new generation of Schepers calls it home, descendants of the original F. W. Scheper, in fact. (Bill Scheper.)

F. W. Scheper, or Freddie, was born in Beaufort in 1872. He attended Judson College in Hendersonville, North Carolina, and the Bergman School for Boys in Charleston. He then succeeded his father in ownership of the Scheper Store in Port Royal and became one of the town's leading merchants. In addition to being a ship chandler, wholesale and retail grocer, and dealer of hay and grain, the younger Scheper also served as an agent for the Propeller Tow Boat Company of Savannah and Pilot Boat No. 1. He was appointed postmaster of Port Royal in 1907. He was also the 12th mayor of Port Royal. Freddie Scheper was an avid car collector. He was known to have the first automobile in Beaufort. Beatrice, Freddie's wife, is pictured below posing beside the classic car. (Bill Scheper.)

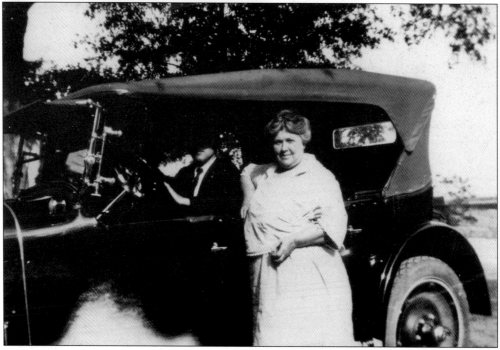

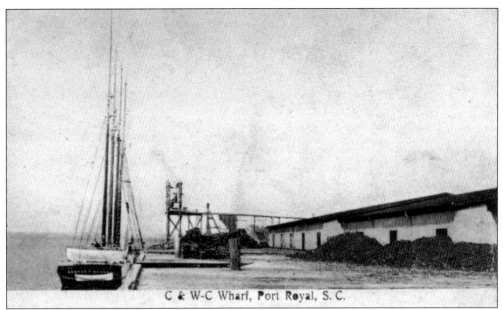

The Charleston and Western Carolina (C&WC) line assumed the Port Royal Railroad and wharf in 1896. Prior to C&WC's acquisition, the wharf in Port Royal flourished as vessels on runs from Florida to New York stopped at Port Royal to load coal brought in from the railroad. Merchants of various commodities used this port because of the natural depth of Port Royal Harbor, accommodating ships up to 10,000 tons. Soon phosphate and lumber mined in Beaufort County became Port Royal's most important trade items. (HPRF.)

The Port Royal Hotel was built in the early 1900s on London Avenue. Owned by the Parks family, the magnificent hotel with water views of the Beaufort River catered to travelers aboard steamships and schooners anchored in Port Royal Harbor. Friends and relatives of the many prospering merchants in town were also guests of the establishment until the town fell into economic despair shortly thereafter. The Port Royal Hotel degenerated into apartments before it was condemned and razed in the 1970s. (HPRF.)

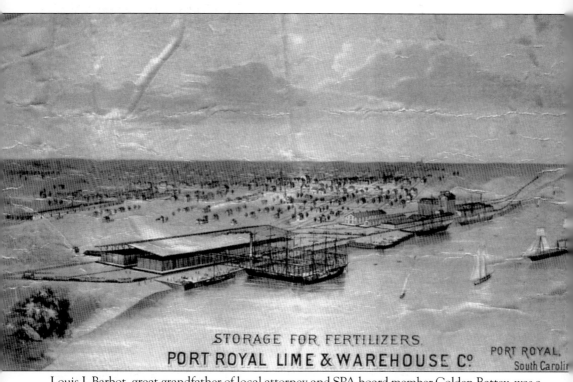

Louis J. Barbot, great-grandfather of local attorney and SPA board member Colden Battey, was a civil engineer in Charleston. He drew this elevation for an English syndicate who had a contract to purchase most of the land in Port Royal, owned by Daniel Appleton in the late 1800s. The investors of the proposed Port Royal Lime and Warehouse Company fell victim to a national financial panic. The ill-fated endeavor was a prelude to Port Royal's near economic demise. During the term of Gov. "Pitchfork" Ben Tillman, when Upstate and Lowcountry interests conflicted, state tax in South Carolina on each ton of phosphate shipped out was increased from $1 to $2. The great Sea Island hurricane of 1893 also destroyed several phosphate mines and closed rail traffic for some time. Merchants obtained phosphate in Florida at a cheaper price, and eventually, the phosphate mines in Beaufort closed. As a result, port and rail activity decreased significantly. (Colden Battey.)

Known as the Bailey House, this structure at 913 Seventh Street was built in 1908 or 1909 by Irvin Magahee, an engineer for the C&WC Railroad. Magahee's daughter Nell and her husband, Curvin Strausbaugh, lived in the house. Later it was purchased by Calhoun Thomas, a local attorney. Bridge contractor Thomas E. Bailey and his family leased the house from Thomas from 1936 until 1939, when Bailey bought it. (Terry Poore.)

This house at 1215 Paris Avenue was built in 1909 by a Captain Dantzler, who used the home as his summer residence. He later built an addition in the rear. The Tyree family bought the house in the late 1930s for $500 and also added an addition on the east side of the house. After the house was purchased in 1999, the rear section was torn down to allow for additional lots. (Martha Ann Tyree Moussatos.)

William Henry ("Willie") Vaigneur, born September 24, 1865, lived on Callawassie Island from 1868 to 1905. While on Callawassie, Vaigneur made a living as a farmer for close to 37 years, but after moving to Port Royal, he changed careers to become a commercial fisherman. Willie and his wife, Rebecca Stone Vaigneur, had seven children: William Benjamin, Lewis, Dora (Milligan), Thomas, Marguerite (Chaplin), Pauline (Harris), and Fred. (Betty Vaigneur Abraham.)

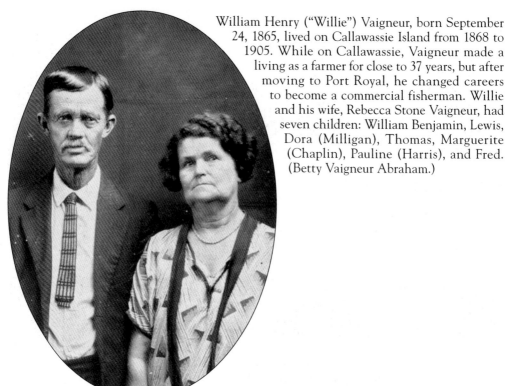

Some descendants of Willie and Rebecca Vaigneur are the five children of Thomas and Lula Walker Vaigneur: from left to right, (first row) James H., Betty (Abraham), and William Thomas; (second row) Pat and William Henry Vaigneur. (Betty Vaigneur Abraham.)

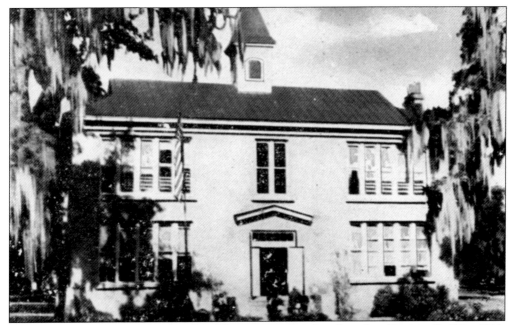

Port Royal Elementary School is the oldest active school in Beaufort County. Built in 1911, the two-story building housed six grades in two rooms until 1954, with a library consisting of three bookcases. There was a fountain in the hall and a sink and faucet on the back porch. The bathrooms, of course, were outside on separate ends of the building, girls on the east and boys on the north, near Fourteenth Street. (HPRF.)

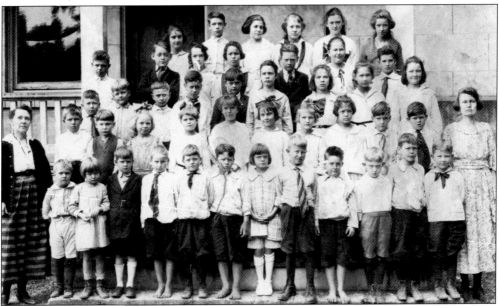

Miss Paul (far left) and Miss Hucklebee (far right) were the only two teachers at Port Royal Elementary in 1922, the presumed date of this picture. In addition to teaching reading, writing, and arithmetic, they were also required to teach Sunday school at the Union Church. Miss Hucklebee rented a room from the Jernigan family, who lived on the corner of Twelfth Street and Paris Avenue. (HPRF.)

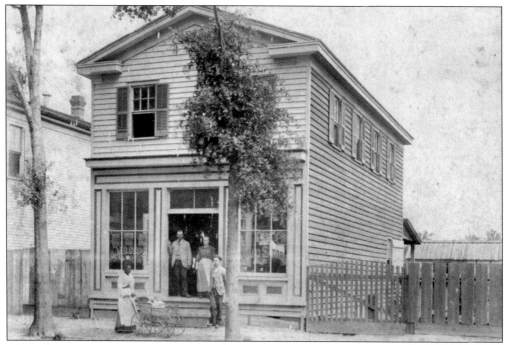

The Cope Drug Store, located at 916 Eighth Street next to the Scheper Store, was one of two drugstores in Port Royal. Dr. Miles Berrien Cope, physician, druggist, and one-time mayor of Port Royal, lived upstairs with his family. Dr. Cope was married twice. Hattie Kinard and Dr. Cope had three children: Janie Elizabeth, Minnie (Wilson), and J. B. Dr. Cope later married Sue Corley of Lexington. (HPRF.)

Frank LaPrade Tyree was born in Mobile, Alabama, in 1889 but moved to Parris Island in 1917. A world-renowned singing instructor classically trained the adolescent as a boy soprano. Tyree performed in Gilbert and Sullivan operettas all over the Gulf Coast. He also played the banjo ukulele in jazz bands. In addition, he was a vaudeville comedian who acted as Mr. Jones in the notorious "Mr. Bones and Mr. Jones" skit. He is fondly remembered by his signature song, "The Holy City," a traditional hymn written by Michael Maybrick. (Martha Ann Tyree Moussatos.)

Margaret Tedder (Rodgers) stands in an old wooden bateau near the old coal shoot. Coal was brought in daily by rail and lifted by crane onto a barge, which transported the commodity to Parris Island. (Margaret Tedder Rodgers.)

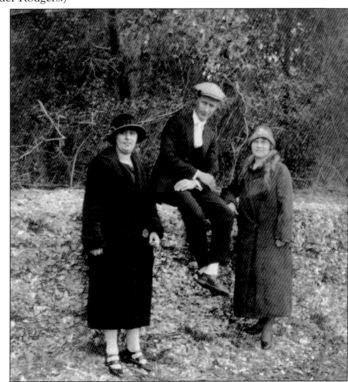

Pictured in the 1920s from left to right, Florrie Humbert, Wheeler Humbert, and Estelle Solomon gather around the tabby ruins of Fort Frederick where the Naval Hospital sits today. The fort was built by a British army unit in 1727, but it was considered too low to protect against enemy fire. Stephen Bull ordered the fort be moved to higher ground, but by 1758, Fort Lyttleton had been erected and Fort Frederick was no longer needed. (Catherine Humbert Mascaro Brooks.)

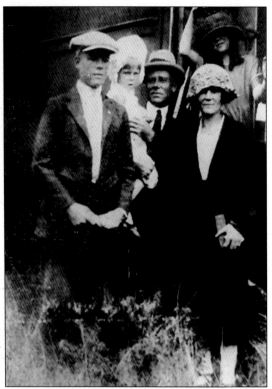

The Tedder family poses in front of the train in Port Royal before their departure to Charleston. They are, from left to right, Raymond C., Harvey Z. holding Margaret (Rodgers), Maggie B., and Rebecca "Becky" (Black). Harvey Tedder was transferred to Parris Island from Charleston as a civilian employee, but his family remained in Charleston so Raymond could finish high school. In the summer, the Tedders lived in the apartment above the old post office where the postmistress kept a boardinghouse.

Sisters Evie Magahee (Gray) and Nell Magahee (Strausbaugh) stand on the banks of Battery Creek near the old Port Royal dock, where the future Ports Authority would later construct Pier 21. The large concrete footer in the background remained as scrap after several were loaded by means of a crane onto a barge and transported during the construction of the Harbor River Bridge. (Doris and Sammy Gray.)

Hattie Platt Harter moved to Port Royal in 1926 with her husband, John Perry Harter, and lived on London Avenue. Florrie Humbert, who lived around the corner on Eighth Street, and Hattie Harter were best friends but would only refer to each other as Mrs. Humbert and Mrs. Harter. The formal salutation was customary for Southern women. Not only was it polite, but it also announced their mutual respect for one another, mother to mother. (Sandie Foster Tucker.)

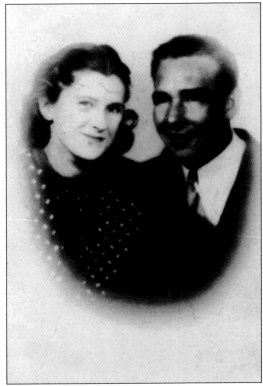

Corrie and Hugh Rahn married in Bluffton and came to Port Royal from Springfield, Georgia, in 1927 as newlyweds. Mr. Rahn worked at the power plant on Parris Island that produced electricity and high-pressure steam for heating the buildings on base. Mr. Rahn retired from government service after 39 years as the supervisor of utilities for Parris Island. The Rahns raised five children on Smilax Avenue in Port Royal: Merle (Horton), Mickey (Vaigneur), Buckey, Ned, and Hilda Rahn. (Faye and Ned Rahn.)

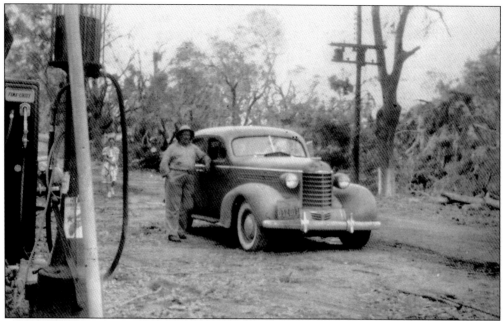

Frank and Vireen Tyree operated a country store and service station next to their home at 1215 Paris Avenue, where this picture was taken. Mr. Tyree leans against a four-door Chevy sedan while observing damage from the hurricane of 1940. Storms weren't named until 1950. This hurricane had sustained winds of 90 miles per hour and was responsible for 10 lives lost in Beaufort County. An estimated $1 million in damages occurred. (HPRF.)

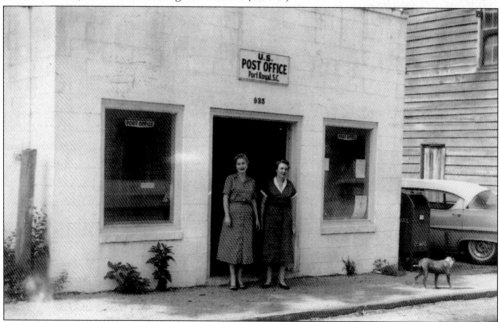

Standing in front of the second of four U.S. post offices in Port Royal are Janette Tisdale (left) and Emily Bishop. Mrs. Bishop was the longest-serving postmaster in Port Royal's history, with over 30 years of dedicated employment. Mrs. Bishop established door-to-door delivery in Port Royal, and through her efforts, the City of Beaufort failed to absorb the town's post office. (HPRF.)

The Order of the Eastern Star is the largest fraternal organization in the world to which both men and women may belong. It is a Masonic-related group comprised of people with deep religious convictions and spiritual values and open to all faiths. This picture shows members of the Faith Chapter No. 167 of Port Royal in fellowship after one of the order's degree presentation ceremonies. The degrees teach lessons of fidelity, constancy, loyalty, faith, and love. (Lottie Shynkarek Phinney.)

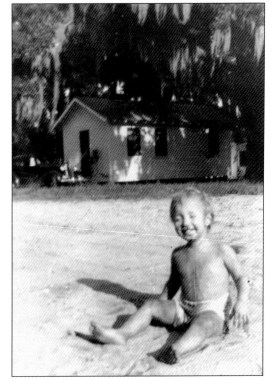

Lottie Shynkarek (Phinney) plays in the dirt in front of her house on Fourteenth Street. Behind her is the Bogan's rental house, which was moved from Parris Island. Lottie married Waldo Phinney Jr. in 1963, and they later made their home in Shell Point. She is a registered nurse who has worked with Beaufort Memorial Hospital since 1968. She is currently the coordinator for infection control and employee health. (Lottie Shynkarek Phinney.)

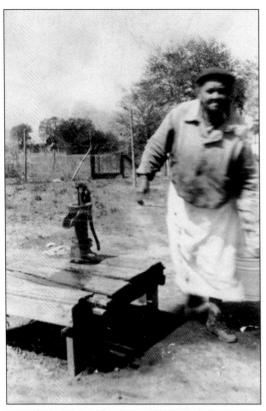

Barnetta "Pinky" Jackson lived at 1113 Twelfth Street in a house known today as the "Ma Pink House." In this rare photograph (perhaps the only photograph of Mrs. Jackson), she carries water pumped from her backyard well. Pinky adopted Herbert Jackson, below, when he was a young boy. The young man herded Pinky's cows to vacant lots every day to graze and always carried a pole to grab moss from the trees to feed the cows. He sang beautiful hymns as he walked down Paris Avenue. Years after Pinky's death in 1954, Herbert continued to walk Paris Avenue, pole in hand, guiding the invisible cows to the vacant lots. The hymns never changed: "Silent Night," "Kum Ba Yah," and "Michael Row the Boat Ashore." Some years later, Herbert, nicknamed Tootie Frootie, led the band at Robert Smalls High School. Jim "Papa" Watson had a plaque made for Herbert recognizing his contributions to the school. (Ben Jackson and Alice Wilson.)

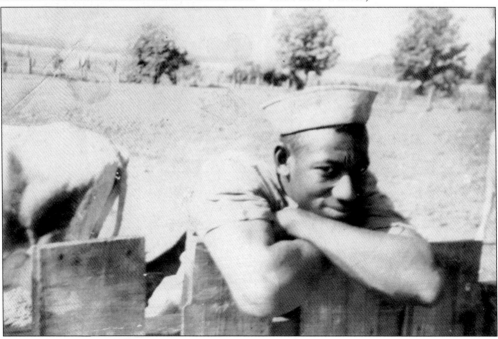

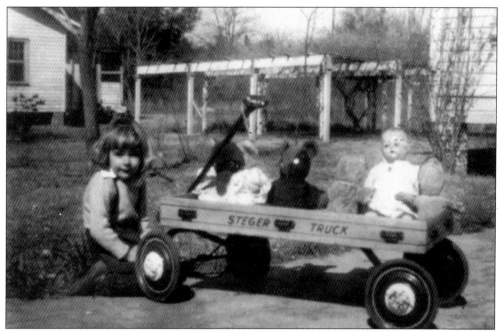

Hilda Rahn was the youngest of five children. In this photograph at her home on Smilax Avenue, Hilda prepares her dolls and stuffed animals for a ride in her Steger truck, a wood chuck-wagon similar to the Radio Flyer, both of which go for considerable amounts of money today on eBay. (Faye and Ned Rahn.)

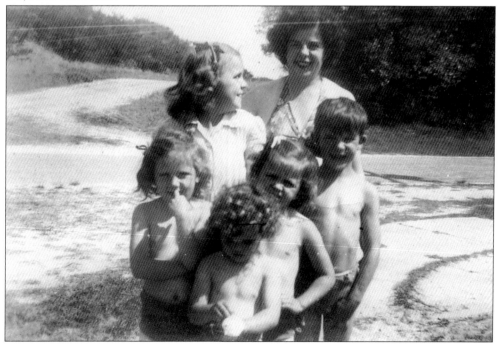

Catherine Stentiford Phinney stands with her children—Betsy (Harter), Priscilla (Parmley), Marilyn (Graddy), Janet (Woodrich), and Waldo "Wally" Phinney Jr.—after an enjoyable day in the river. (Lottie Shynkarek Phinney.)

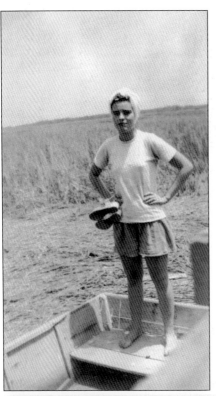

Catherine Humbert (Mascaro) (Brooks) stands at the stern of an old bateau at the end of Eighth Street before Port Royal Harbor was dredged and the marsh and creeks were filled. She recalled Curvin Strausbaugh owning a waterfront bait shop at the end of Seventh Street, where he sold tackle and rented rowboats for fishing. The creek was known as Big Creek. (Catherine Humbert Mascaro Brooks.)

Dolly and Fate Coates lived on Fifteenth Street in a house moved from Parris Island. Mr. Coates was a pastor who preached at Zion Baptist Church, which was located next door to his house. Mrs. Coates was known in Port Royal as the first African American woman in town to champion civil rights. (Alice Wilson.)

Helen Harter Foster described the residents of Port Royal as "simple, honest people; people who were real, people who wanted leadership in government and a clean environment." She delighted in a good political debate and stayed active in the town to ensure the rights of all citizens were upheld. The covered oyster shed at Live Oaks Park in Port Royal is named for Mrs. Foster. (Sandie Foster Tucker.)

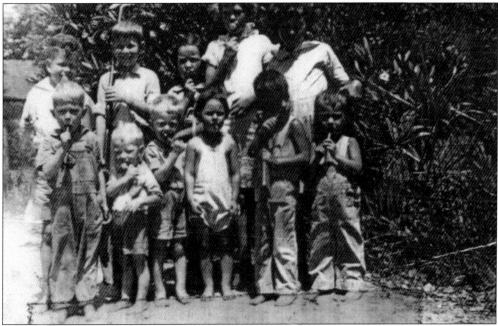

A happy group of Port Royal children enjoys lollipops in front of the Paul-Pointe House on Seventh Street. They are, from left to right, (first row) unidentified, Charles Morris, J. W. Morris, unidentified, John "Sonny" Carey, and Patrick Carey; (second row) Fred Lancaster, Harold Gray, Jeanette Bazemore, Gilda Vaigneur, and Yvonne Carey (Butler). The photograph was taken in 1941. (HPRF.)

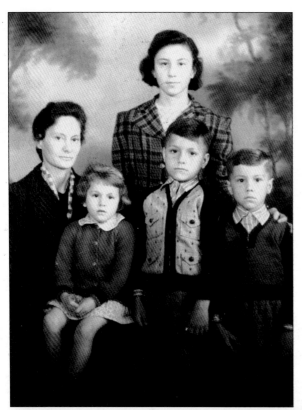

While her husband was overseas, Marie Carey rented a house where she kept a garden and raised chickens. She only received $50 a month from the U.S. government, so she made wise choices in regards to necessities. Lemuel Ritter, who worked for the Laundry at Parris Island, brought Mrs. Carey civilian clothes that recruits would throw away. She cut the pants down for her boys and saved enough material to make the girls' underpants and dresses. They lived within their means but found wealth as a devoted family. In the photograph at left, Rose Mary (Marion) sits on Marie Carey's lap. Standing from left to right are Yvonne (Butler), John "Sonny" Jr., and Patrick Carey. John and Marie Carey, pictured below with their pastor, were members of the Port Royal Methodist Church. (The family of Yvonne Carey Butler.)

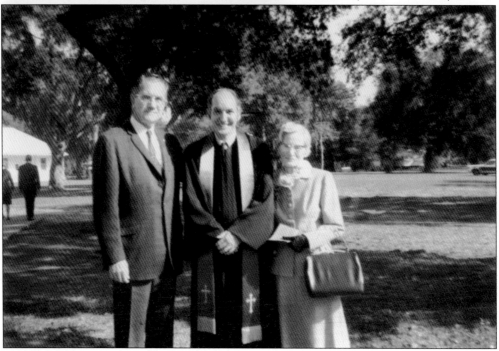

Rose Mary Carey (Marion) sits at a desk placed outside Carpenter's Hall by her teacher, Mrs. Kirkland. Since it was such a nice day, Mrs. Kirkland decided to hold class in the great outdoors. The only two rooms at Port Royal Elementary School were unavailable, so Carpenter's Hall was used as a kindergarten the first year it was started. (HPRF.)

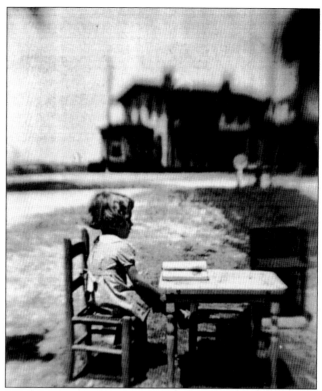

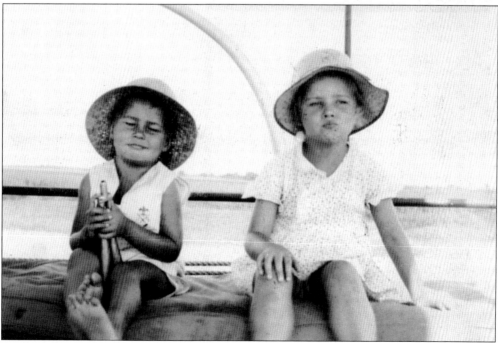

F. W. "Willie" Scheper III and his sister, Margaret Scheper (Trask), enjoy an afternoon on the Beaufort River, a pastime revered in the Lowcountry. The Schepers were avid boaters; they still enjoy the salty breezes off the mighty Atlantic. (Bill Scheper.)

Louise Sauls (Doerr) was the eldest of seven siblings. Yvonne Carey (Butler) and Louise were good friends. They worked at the Oceanview Café on Bay Street in Beaufort after school every day from 3 p.m. until 9 p.m. They had to wait for the bus that came at 11 p.m. to take them to the corner of Ribaut Road and Paris Avenue. From there they would walk home and do it all over again the next day. (Lottie Shynkarek Phinney.)

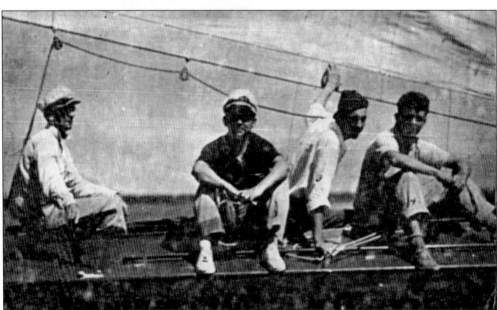

From left to right, Edward Burton "Burt" Rodgers, F. W. "Willie" Scheper Jr., Richard "Dick" Bray, and T. Legare Rodgers take a break from sailing the *Syndicate*. The boat and her crew won many sailing regattas locally and regionally in the South Atlantic Racing Association. (Bill Scheper.)

Sitting in front of the pilothouse on the *Owanee* are, from left to right, Margaret Scheper (Trask), Jane "Mookie" McTeer (Woods), Georgiana McTeer (Cooke), and Sally McTeer (Chaplin). The Schepers often invited the McTeers aboard the *Owanee* and anchored behind Capers Island for several days at a time. The families would play on the beach by day and board at the McTeers' camp on Capers by night. (Bill Scheper.)

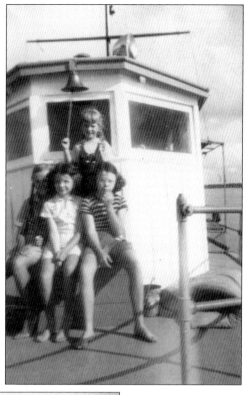

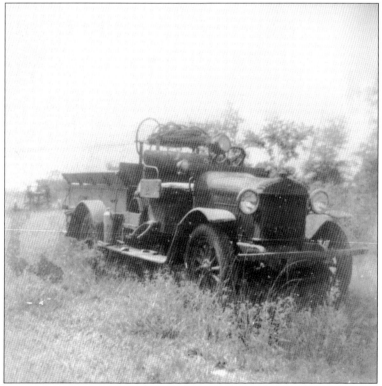

This fire truck was purchased in 1946 for $900 as a surplus item for the town. It was replaced in 1958 by a Howe fire engine that had a price tag of $10,000. In 1958, Port Royal's fire chief, W. T. Smith, and assistant chief A. R. Horne reported to a board of fire masters consisting of Joseph Haskell, Rev. R. C. O'Donnell, Billy Funderburk, Frank Cheasman, and Al Mascaro. This group also supervised the volunteer fire department. (Catherine Humbert Mascaro Brooks.)

Merle Rahn (Horton), left, and Gilda Vaigneur stand under the awning at Metcalf's Grocery Store. Doris Kent Metcalf (Morrall) and her husband, Elmo, operated the general store, meat market, and lumberyard office. (Faye and Ned Rahn.)

Elmo Metcalf was a 32nd-degree Mason active in the Port Royal Lodge, a town councilman, and mayor pro-tem. He died in 1951 at 35 years old of a kidney ailment. He and his wife, Doris, had one daughter, Toni Metcalf (Goodwin). (Kent Bishop and Toni Metcalf Goodwin.)

Lois DeLoach (Randall), affectionately known by her husband, Myles, as "Ice House Katie," worked in the icehouse on the docks. The Randalls were members of the Union Church. When the church began to look for a piano, Mrs. Randall donated her M. Schulz Company piano. It was manufactured around the beginning of the 20th century and thought to be 40 or 50 years old when she donated it in 1941. (HPRF.)

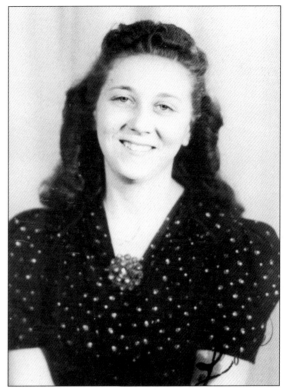

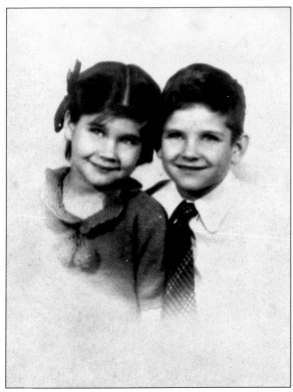

Mickey (left) and Buckey Rahn were twins born November 14, 1929, within a few days of Grace Patricia Kelly, actress and princess of Monaco; Dick Clark, American entertainer; and Edward Asner, actor. Also in November 1929, the Museum of Modern Art opened in New York City, the Ambassador Bridge opened to international traffic, and a Richter magnitude 7.2 earthquake struck the Grand Banks off Newfoundland. It was a historic year indeed. (Faye and Ned Rahn.)

From left to right, Oti Shynkarek (Marsden), David Bogan, and Lottie Shynkarek (Phinney) take a break from America's pastime to say cheese for the camera. When Lottie and Oti weren't playing ball, they stayed in the playhouse their father had recycled from an old outhouse. They spent countless hours cooking, entertaining, and mothering their dolls in the miniature house. (Lottie Shynkarek Phinney.)

From left to right, Gerald, Eddie, and Caskell Sauls gather around their baby sister, Oti Shynkarek (Marsden). Oti recalled her brothers taking great care of her. They would take her to Metcalf's store, where she would get a banana Popsicle, a Nutty Buddy, or an ice-cream sandwich. When Gerald broke his arm and had it elevated in a cast, he still took Oti on the handlebars of his bike for the daily treat. (Lottie Shynkarek Phinney.)

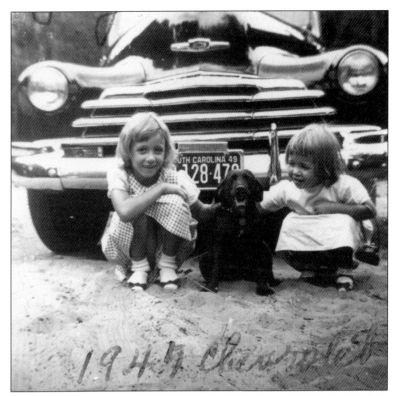

Lottie Shynkarek (Phinney), left, and her sister, Oti Shynkarek (Marsden), pose with their dog Lilly in front of their daddy's 1947 Chevrolet four-door sedan. The picture was taken in 1949, as confirmed by the date on the license plate. (Lottie Shynkarek Phinney.)

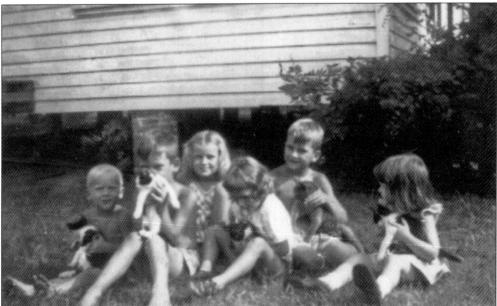

From left to right, Johnny and Richard Clement, Patty and Barbara Collins, and Ned and Hilda Rahn frolic with kittens for an adorable photograph. The pairs of siblings were all neighbors in Port Royal. Ned especially liked animals. He once kept a heron that took over the family's chicken coop for weeks. He also collected frogs and kept them in his sister Mickey's room. When she'd prepare for dates, she would get quite surprised to find frogs hiding in her shoes. (Faye and Ned Rahn.)

This group, dominated by cousins, gathered for a photograph while taking a break from swimming in the river. They are, from left to right, (first row) Bobby Chaplin, Judy Harris, Jack Chaplin, Jimmie Vaigneur, and Paul Bazemore; (second row) Marguerite "Teter" Chaplin, Tommy Vaigneur, Isabel Harris, Ruth Chaplin (Hejduk), Gilda Vaigneur, and Bill Chaplin. (Jack and Sally Chaplin.)

Erma Sauls Shynkarek presides over a Junior GA Presentation Service at the Port Royal Baptist Church. The GA program is part of the Women's Missionary Union, an auxiliary of the Southern Baptist Convention. Presentations of step emblems are awarded to girls who are passed by the review council. These steps include Maiden, Lady-in-Waiting, and Princess. A coronation service was held for the recognition of queen and the optional step queen-in-service. (Lottie Shynkarek Phinney.)

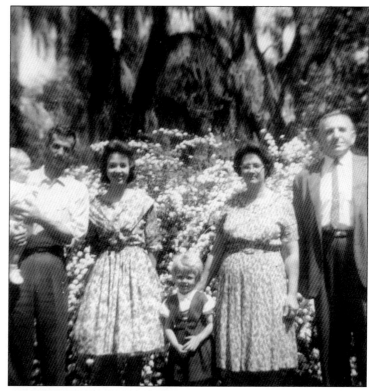

Spring in the Lowcountry means Spanish moss hanging from centuries-old live oaks with multi-colored azaleas in bloom to surround them. For many, these four to six weeks when azaleas bloom and temperatures average in the upper 70s are the most beautiful days of the year. Celebrating spring in the backyard of their Fourteenth Street home are, from left to right, Eddie Sauls holding his son, David; Oti Shynkarek (Marsden); Debra Sauls (Robinson); Erma Sauls Shynkarek; and Joe Shynkarek. (Lottie Shynkarek Phinney.)

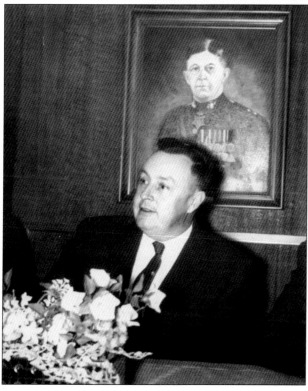

James Lemuel Ritter was the mayor of Port Royal for 26 years, from 1938 to 1966, with a two-year leave of absence to serve in World War II. Ritter was an active member of the civic and religious community during his tenure as mayor. As a hobby, Ritter researched and collected early maps of the southeastern United States. The former mayor publicly challenged the location of Charlesfort, contending it was built in Port Royal, not Parris Island. (Ann Ritter Holmes.)

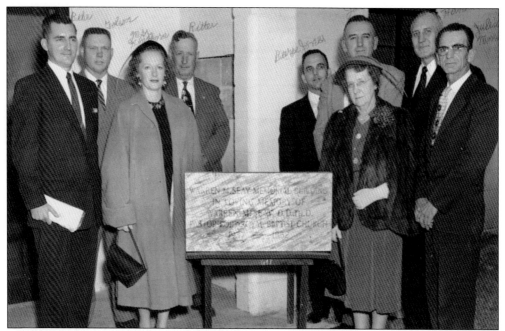

At the dedication of the Warren C. Seay Memorial Building at the Port Royal Baptist Church are, from left to right, Rev. Earl Behr, Dave Tolson, Julia Seay Kinghorn, Emeal Ritter, George Jones, Joe Shynkarek, Dorothy Kerr Smith Seay, Mr. Hammett (a representative from the Southern Baptist Convention), and Julius Morris. Warren Seay was a pastor at Port Royal Baptist Church for 16 years. (Lottie Shynkarek Phinney.)

From left to right, Nancy Hall, Ann Gray (Lubkin), and Louise "Baby Lou" Lubkin (Smalls) smile for the camera while relaxing on Pritchard's Island. Baby Lou, a Beaufort resident, invited several friends from Beaufort High to "the camp" at Pritchard's for a day of fun in the sun, including the two gals from Port Royal. (Martha Ann Tyree Moussatos.)

Ned Rahn rides his tricycle through the grass in his backyard on Smilax Avenue. In the background is an arbor of muscadine grapes built by Ned's father, Hugh, who hand-fabricated all of the posts and supports using cement. The muscadine, or scuppernong, is a native Southern grape well adapted to warm, humid conditions. They can be eaten fresh from the vine or made into jams and jellies, as well as a favorite, scuppernong wine. (Faye and Ned Rahn.)

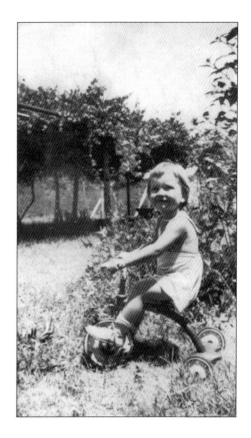

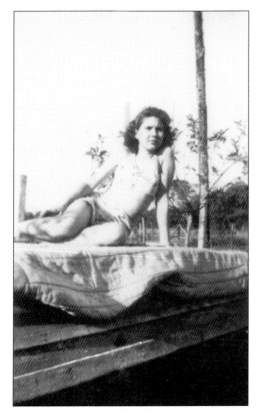

Mickey Rahn (Vaigneur) takes a break from sunbathing atop her improvised lounge chair. She turned her daddy's bateau over, threw a quilt on top, and dreamed of pool boys and piña coladas in the backyard of her home on Smilax Avenue. (Faye and Ned Rahn.)

Ogden Lazenby, son of Mary Jane Searson and Bovay Alfred Lazenby, grew up on the corner of Thirteenth Street and Columbia Avenue, where Carolina Hospice now resides. Ogden received a bachelor of arts degree from Abilene Christian College and a master's degree from Florida State University. He was a preacher, served in the U.S. Army, and fished commercially. Lazenby also taught in Beaufort; Okinawa, Japan; and Berlin, Germany. Since retiring, Ogden continues to fish and works at Gay Seafood in Port Royal. (Ann Ritter Holmes.)

Benjamin Jackson married Jestine Smalls Jackson, also a native of Port Royal. Jestine walked to school everyday from Port Royal to Robert Smalls High School, located where the present-day Beaufort County Courthouse sits. The Jacksons had five children: Benjamin Jr., Shirley (Weldon), Vernell (Fyall), Ronald, and Larry Jackson. (Ben Jackson.)

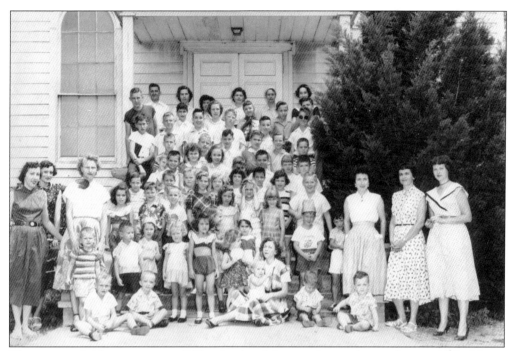

These young children in vacation Bible school and their teachers gather on the steps of the Union Church in 1955. Many of the church activities took place at Hunting Island in the summer. The big pavilion was always reserved for the outings. Surely many of these children have memories of the good food, jumping from the tall dunes, and climbing the lighthouse. (Ann Ritter Holmes.)

Clarence "CC" and Mabel Brown were active in the community. During vacation Bible school, the youth would load up in the back of Mr. Brown's wood-sided flatbed truck and ride to Hunting Island, where Mrs. Brown and other mothers would be waiting to serve a picnic of home-cooked goodies. Brown served as the town's mayor when Lemuel Ritter took a leave of absence to serve in World War II. The Browns owned the Red Bird Cab Company on Ninth Street. (HPRF.)

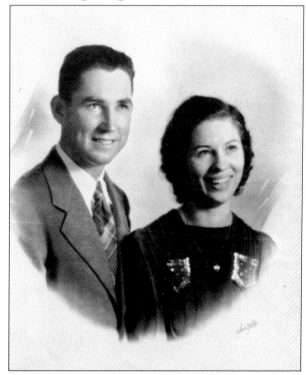

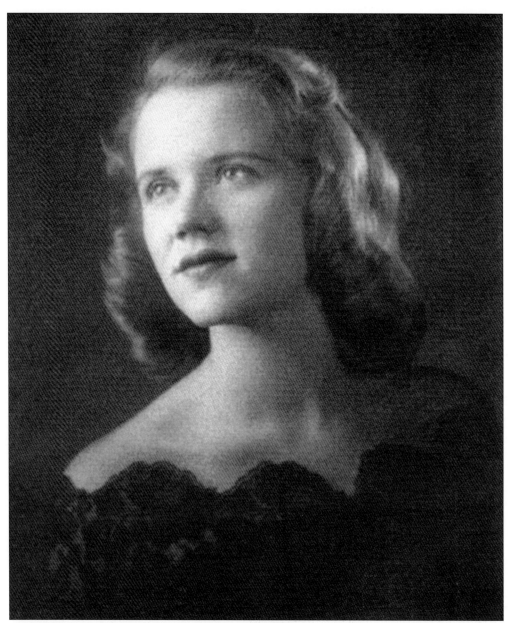

Martha Ann Tyree (Moussatos) poses for her Columbia College senior picture. After graduating as valedictorian of her Beaufort High School class, Martha trumped her feat by graduating valedictorian of her Columbia College class, where she majored in English, library science, and creative writing. She wrote a three-act historical drama, *Young Eliza*, at Columbia, which was produced her senior year. After receiving a master of library science degree from the University of Arizona, she became depot librarian at Parris Island Marine Corps Recruit Depot. Martha has won numerous literary awards and has published poetry and feature articles in *Sandlapper* magazine, *South Carolina Librarian*, *The Savannah Morning News*, *The State* newspaper, *The Poetry Society of South Carolina* yearbook, and *Leatherneck*. She also published a book of poetry, *Scuppernong Wine at Room Temperature*, as well as a collection of recipes, *The Sandlapper's Salvation Cookbook*. (HPRF.)

Kent Bishop poses with his horse, Red, in his backyard at 1107 Thirteenth Street. His father, Clyde Bishop, built the home with recycled wooden crates that carried medical supplies to the Naval Hospital daily. Bishop still resides at this home on Thirteenth Street. (Kent Bishop and Toni Metcalf Goodwin.)

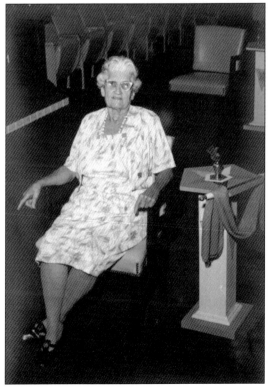

Kate Edmunds Kirkland was Port Royal's only female mayor. Her husband, Haston Wyman Kirkland, died in 1934 while serving his third term, and Mrs Kirkland filled the position upon his passing. In addition to holding office, Kate Kirkland was also the town's storm tracker. For years, she raised flags on the weather tower at the end of London Avenue to notify the townspeople of inclement weather. It was Port Royal's original hurricane warning system, though it's unknown how Mrs. Kirkland got her information. (HPRF.)

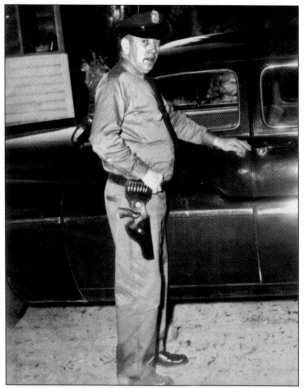

Gordon Cole was Port Royal's police chief in 1959 after retiring from the U.S. Marine Corps in 1950. Gordon and his wife, Bertha Shultz Cole, raised nine children on the corner of Eleventh Street and Thirteenth Avenue: Geraldine (Colter), Marion (Corbett), Estelle (Hendricks), Gordon Jr., Howard, Garland, Glenn, Walter, and William Cole. (HPRF.)

From left to right, siblings Ruth Harter Canas, John J. "Pie" Harter, and Helen Harter Foster, children of Hattie and Joseph Harter, grew up in Port Royal on London Avenue. Pie Harter was the 21st mayor of Port Royal. In fact, he named one of his shrimp boats *Hizzoner* (pronounced His Honor) to publicize his position, symbolic of his witty personality. (Sandie Foster Tucker.)

George (left) and Riley "Butch" Randall pose for a picture while the elder takes a break from mowing their West Parris Avenue lawn. George Randall was born November 15, 1915, on Beech Island, a son of Ethel Mae and Jeter Randall. They moved to Port Royal in 1917, and in 1918, Ethel became postmistress of Port Royal. (HPRF.)

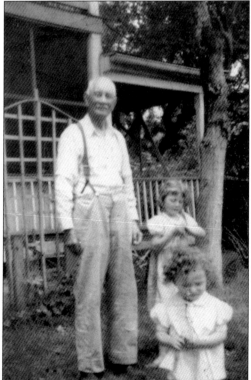

PaPa Davis was the telegraph operator in Port Royal. He also sold milk and butter to town residents. He is pictured here with two unidentified children in front of his house on London Avenue, which was located next to the Harter houses. He was known as a very kind man to the children of Port Royal, all of whom he gave a nickname. (HPRF.)

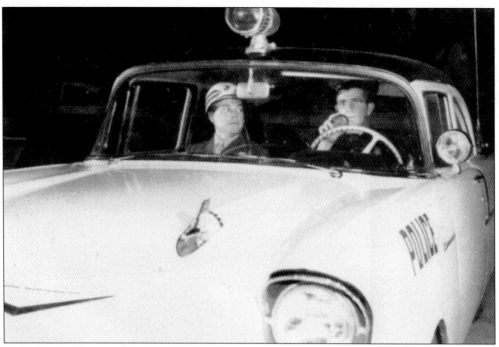

Myles Randall became Beaufort's chief of police in 1962. A native of Port Royal, Mr. Randall had 13 years of experience as a patrolman before being appointed to chief. This picture was taken in 1957. Randall is talking on the radio as a military policeman looks on. (HPRF.)

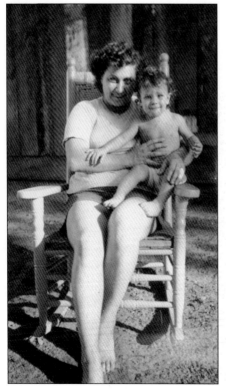

Sandie Foster (Tucker) sits on the lap of her mother, Helen Foster. Sandie's grandmother, Hattie Harter, lived across the street, and her parents, Helen and Bill Foster, lived on Eleventh Street. She had the best of both worlds within walking distance from one another: mom's delicious sour-cream pound cake and grandma's hugs and kisses. Sandie was later crowned Miss Beaufort and won Miss Congeniality in the Miss South Carolina pageant. (Sandie Foster Tucker.)

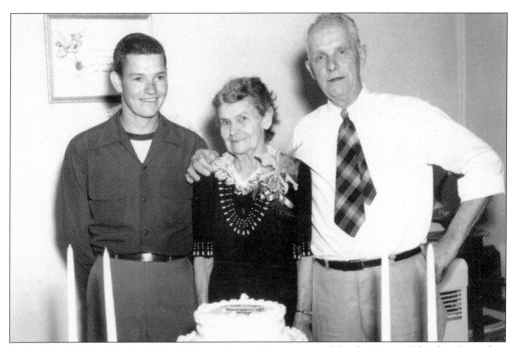

Saxby "Jack" Chaplin Jr. (left), Rebecca Stone Vaigneur, and Saxby Stowe Chaplin Sr. gather around the cake made for Mrs. Vaigneur's 80th birthday. Marguerite Vaigneur married Saxby Chaplin on October 8, 1919, at the home of Marguerite's mother, Rebecca (center). Jack is Marguerite and Saxby's oldest son. (Sally and Jack Chaplin.)

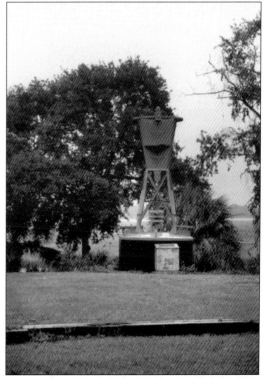

In 1970, this buoy ripped away from its mooring about 15 miles off the town's coast. One year later and 6,000 miles across the Atlantic, the buoy washed up on a beach in Scotland. Local authorities were notified, and the buoy was traced back to the United States through a serial number. It came home in 1973 and was given a permanent residence in the park at London Avenue and Ninth Street. It stands as a tribute to officers who lost their lives in the line of duty. (Town of Port Royal.)

When Marion Jones's mother, Ethel Mae Boineau Jones, was pregnant, she and her husband, Robert, lived on St. Helena Island. The only transportation to and from the island was by boat. The Joneses made arrangements to catch a train from Port Royal to Columbia to deliver the baby, but as they were crossing the river on December 21, 1921, they were engulfed by a severe thunderstorm. Once they reached Port Royal, Mrs. Jones insisted she couldn't go any further. Mr. Jones had a fishing and hunting buddy who lived in Port Royal and who just happened to be entertaining the commander of the Naval Hospital at Parris Island that evening. Fortunately Marion Jones (above) was delivered that night by experienced hands and was raised with a great appreciation of the rivers and creeks of Beaufort County. Ethel and Robert Jones eventually opened a grocery store in Port Royal when truck farming became profitable and moved their family to Beaufort. (Mary Jack Jones.)

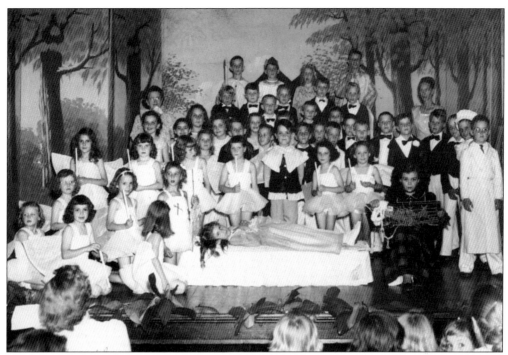

Students at Port Royal Elementary School performed two plays every year in the auditorium located upstairs. These schoolchildren gather around Sleeping Beauty in their hand-sewn costumes made by their parents. Town mothers would also make cakes and cookies to sell at the plays that raised money for the school. (Lottie Shynkarek Phinney.)

Clyde Bishop holds his son, Kent, as his wife, Emily, looks on. Bishop, an army veteran, was the benevolent sort, always helping his neighbors with their homes. After retiring from the army, Bishop worked in civil service on Parris Island. Later in life, he ran a mobile home park in Port Royal, now operated by his son, Kent. Bishop and his wife, Emily, donated the land on which the Port Royal Methodist Church was constructed. They were also instrumental in the development of the Historic Port Royal Foundation. (Kent Bishop and Toni Metcalf Goodwin.)

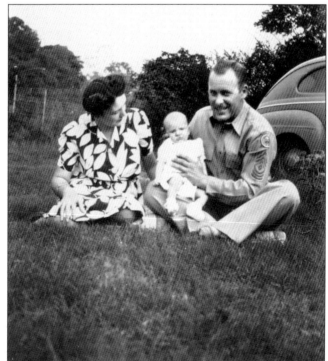

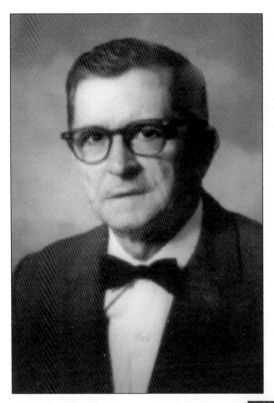

Lowry Graham and his wife, Vienna, moved to Beaufort County in 1942 with their four children, Irma, Venita, Janet, and Bentley. Five years later, a fifth child, Elaine, was born, and they moved to a house on Twelfth Street and Twelfth Avenue. Lowry, a skilled master carpenter, remodeled the house while employed at Parris Island. From 1966 to 1970, Graham served as the town's 20th mayor. (HPRF.)

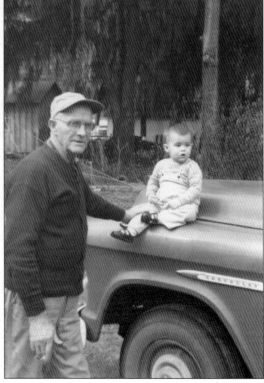

Saxby Chaplin Sr. props his grandson, Gregory Lewis Chaplin, on the hood of an old Chevy truck. Born February 15, 1957, in Beaufort, Greg is the eldest son of Martha and Bobby Chaplin, with whom he still shrimps on the SS *Chaplin*, docked in Port Royal. (Bobby and Martha Chaplin.)

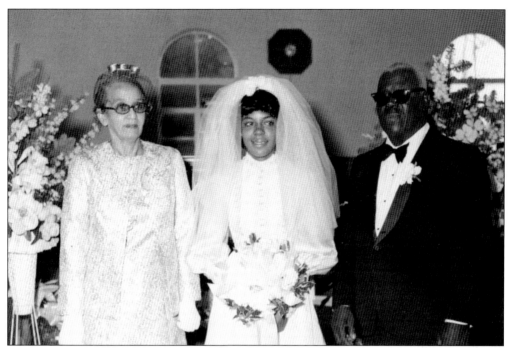

Alice and Charlie Wilson pose with their newlywed granddaughter, Priscilla Ann Green Davis. Davis, who works for a federal judge in Virginia, married a colonel in the army, Donald Davis Sr. They have one son, Donald Davis Jr. (Alice Wilson.)

Clyde Doerr, son of Louise Sauls and Franklin "Chick" Doerr, looks anxious to ride his bicycle. Perhaps he's heading down to the Sands to watch the Army Corps of Engineers dredge Port Royal Harbor, or perhaps he just wants to go to Metcalf's and get his favorite ice-cream cone. (Lottie Shynkarek Phinney.)

Port Royal was a quiet town. Many changes have been made since these photographs were taken. Carpenter's Hall was moved to a new location on Paris Avenue; the SPA erected a fence at the end of Paris Avenue to consolidate their property line; and the railroad station, below, was torn down after Hurricane Gracie. When Marine recruits from nearby Parris Island arrived in Port Royal via the railroad, the town livened up and welcomed the young men with true Southern hospitality. (HPRF.)

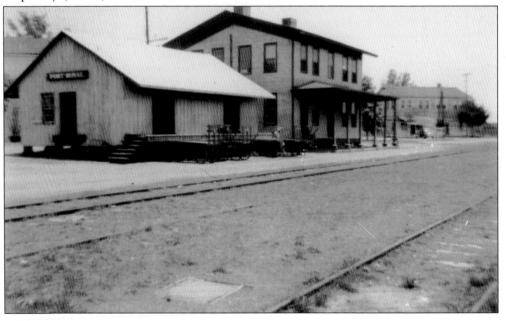

Two
A Marine and Port Affair

After the Battle of Port Royal Sound in 1861, Parris Island became part of the Union occupation of Port Royal Island. Port Royal Harbor became the base for the Atlantic Blockading Squadron. The *New Hampshire* was stationed at Port Royal as a naval training ship from 1877 to 1879, when it was converted into a store and receiving ship. In 1882, construction began on a coaling station and naval storehouse, and the island became known as the U.S. Naval Station, Port Royal, South Carolina. In 1902, the secretary of the navy ordered the Port Royal Navy Yard be moved to Charleston. The base gradually absorbed an officer's training school, a recruit depot, and a disciplinary barracks for the U.S. Marine Corps. In 1915, Parris Island was officially designated as a Marine Corps recruit depot, and the relationship between Parris Island and Port Royal began. All transportation to and from the island was by ferry from the Port Royal docks to the recruit depot docks until 1929, when the causeway and bridge were built over Archer's Creek. Port Royal became the home to many civil service employees and military personnel. The town's economy relied on the peak training loads of recruits. In wartime, thousands of recruits flooded Port Royal en route to their 12-week training. In World War II alone, 205,000 recruits were trained at the depot. Many of these recruits found love in Port Royal. Upon their return from overseas, several stayed and married. After years of economic decline, the small town began to see signs of revitalization. Historic homes were refurbished, stores reopened, and a new mayor began his grand tenure. A notable sense of pride emerged. In 1958, the SPA dedicated Pier 21 at the Port of Port Royal. Despite high expectations, port activity was minimal. Both the U.S. Marine Corps and the SPA brought considerable attention to the shy town, but neither could sustain Port Royal entirely. The town experienced slow growth but remained optimistic.

In 1715, Col. Charles Parris purchased an island in Port Royal Harbor, gave it his name, and started a plantation. Marines first landed on the abandoned island in 1861 as part of the Union occupation during the Civil War. Parris Island became a coaling station and naval warehouse until 1902, when the navy yard moved to Charleston. In 1915, Parris Island was officially designated as a Marine Corps recruit depot. (HPRF.)

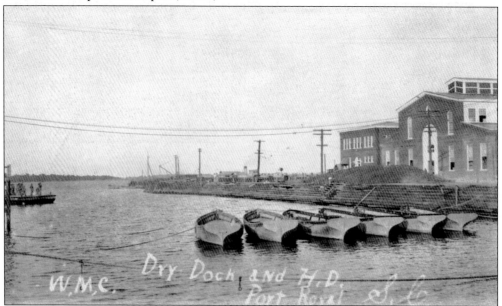

In 1891, the largest wooden dry dock ever built by the U.S. government was dedicated by the Honorable William Elliott at Parris Island. It had the capability to pump 75,000 gallons of water per minute and could fill the basin in an hour. For eight years, until the navy yard was permanently moved to Charleston, Parris Island was among the U.S. Navy's principle repair facilities on the East Coast. (HPRF.)

During World War I, Parris Island recruits arrived in Yemassee on the Atlantic Coast Line Railroad and were transferred to the C&WC Railroad. After arriving at the Port Royal railroad station, they boarded a passenger ferry or kicker boat to Parris Island because there was no bridge to the mainland until 1929. Ultimately 50,000 troops passed through Port Royal on the way to boot camp. (Catherine Humbert Mascaro Brooks.)

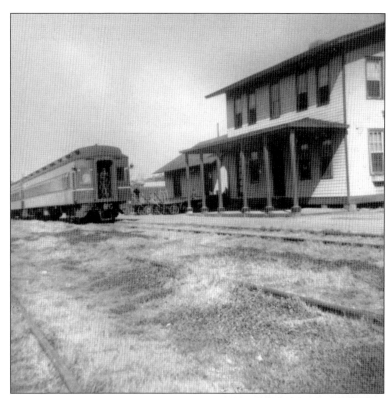

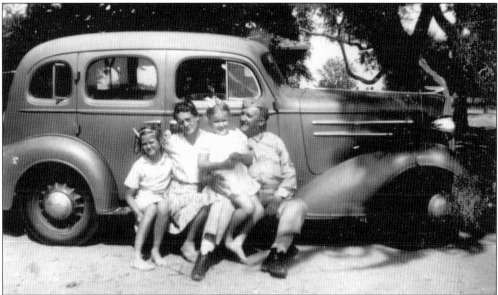

From left to right, Rozena Sauls (Anderson), Vireen Varn Tyree, Martha Ann Tyree (Moussatos), and Frank LaPrade Tyree pose in front of the Tyrees' car. Mr. Tyree graduated from Auburn University in 1909 and became a high school principal before enlisting in the U.S. Marine Corps in 1917, two years after Parris Island became a recruit depot. He was what veterans called an "Old Corps Marine." Tyree retired as a warrant officer in 1947 after 30 years with the corps and made his permanent home in Port Royal. (Martha Ann Tyree Moussatos.)

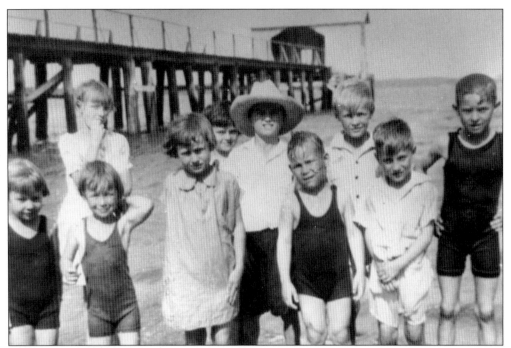

Surrounded by unidentified children, Helen Harter (Foster) (fourth from left) and her brother Pie Harter (with hat on) stand next to the old coal shoot in Port Royal. Shipments of coal once came in by rail and were loaded onto barges en route to Parris Island. After the coaling station closed, the area became a popular hangout for children. (Sandie Foster Tucker.)

John Carey enlisted in the Marines in 1930. He was a guard at the navy prison on Parris Island, and when the prison closed, Carey received orders to become dockmaster in Port Royal. He picked up recruits and supplies in Port Royal by boat and carried them to Parris Island before the Battery Creek Swing Bridge was constructed. Upon returning from overseas in 1944, John Carey became sergeant major of the rifle range and retired in 1946. (The family of Yvonne Carey Butler.)

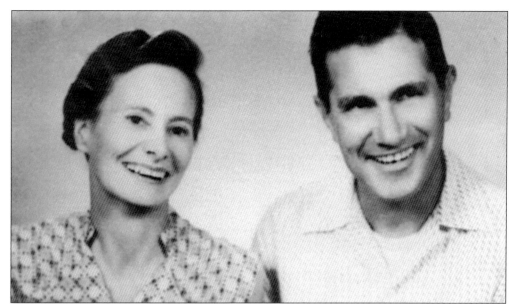

Marie and John Carey were raised in Arkansas on farms a few miles from each other. They moved to Port Royal, where Mr. Carey became dockmaster for the U.S. Marines. The Careys were generous people. They had a farm at the rifle range on Parris Island and, after picking, would distribute rations of vegetables to their neighbors. They also shared ice and coal given to them by the government for cooking and heating since the Careys lived in quarters off base. (The family of Yvonne Carey Butler.)

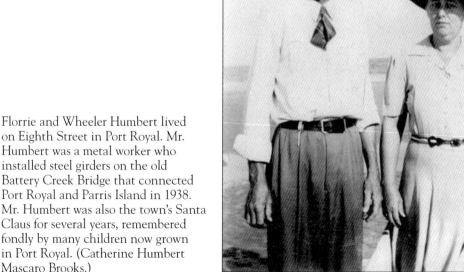

Florrie and Wheeler Humbert lived on Eighth Street in Port Royal. Mr. Humbert was a metal worker who installed steel girders on the old Battery Creek Bridge that connected Port Royal and Parris Island in 1938. Mr. Humbert was also the town's Santa Claus for several years, remembered fondly by many children now grown in Port Royal. (Catherine Humbert Mascaro Brooks.)

Waldo Phinney Sr. served in the U.S. Marine Corps for 31 years before he retired in 1957. He won the Daniel Boone Trophy for marksmanship and taught recruits at Parris Island. Phinney was also a bodyguard to Pres. Franklin D. Roosevelt in 1934 while stationed in Quantico, Virginia. In Port Royal, he was known as the "Man of the Sea." This photograph was taken at Bay Point. (Lottie Shynkarek Phinney.)

During the early 1930s, while stationed overseas, Joe Shynkarek posed in front of the ill-fated USS *Arizona*. On December 7, 1941, the ship, in dock at Pearl Harbor for repairs, came under attack by Japanese aircraft. The USS *Arizona* lost 1,177 members of her crew on that morning and, during the next few years of World War II, came to symbolize the very reason the United States was fighting in the war. *Arizona*, we remember you. (Lottie Shynkarek Phinney.)

After that fateful December 7, 1941, morning, 5,272 recruits arrived in Port Royal, with 9,206 arriving the following month en route to Parris Island. When they got off the train at the Port Royal railroad station, drill instructors hurried them into formation, lining them up on Paris Avenue and calling their first orders while the nervous young men waited to be transported to Parris Island. It was the final segment of the journey to boot camp, where they would learn everything from personal hygiene and cleanliness to martial arts training and Marine Corps history. Recruits had to meet a minimum standard of fitness, qualify with the M16A2 service rifle, and pass a 54-hour simulated combat exercise known as "the Crucible" to graduate and earn the title of United States Marine. (Catherine Humbert Mascaro Brooks and HPRF.)

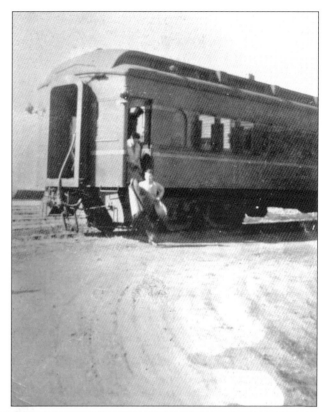

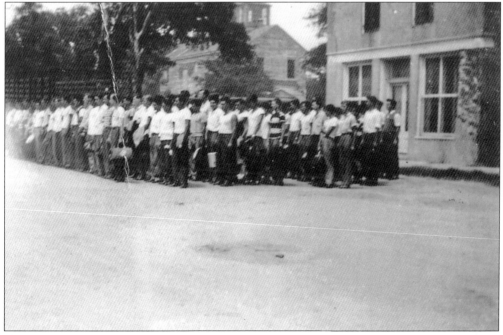

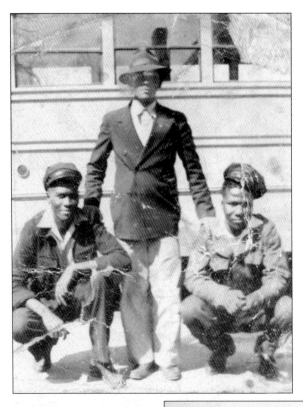

Ben Jackson (center) stands between his friends Harold Lee (left) and Charles ?. The three worked as cab drivers hauling recruits en route from Yemassee to Port Royal. Jackson also worked on a shrimp boat for George Randall, for the Blue Channel Corporation, and for the Town of Port Royal. But he worked construction for most of his life as an operator of heavy types of machinery. Some of his most noteworthy projects include the barracks at Parris Island, the missile pad at Cape Canaveral, the Byrns Bridge to Hilton Head, a military base in Virginia, and the Beaufort Marine Corps Air Station. (Ben Jackson.)

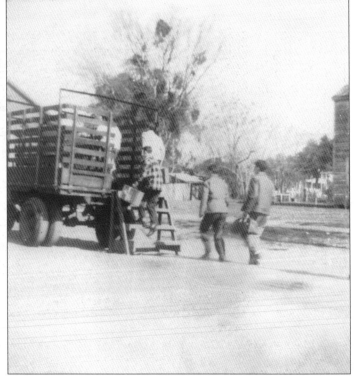

Recruits were herded like cattle onto trucks simply enclosed by wooden sideboards. Drill instructors crammed as many recruits as possible in the tiny space, quickly adapting them to the Marine Corps lifestyle they would experience over the next 12 weeks. Stress was constantly applied to teach recruits how to work under pressure, pivotal in surviving combat situations. Initial training at Parris Island ranked among the hardest military training in the world. (Catherine Humbert Mascaro Brooks.)

James "Jim" Watson, better known as "Papa" or "Itty Bitty," was a Montford Point marine. Montford Point was a segregated training facility at Camp Lejeune, North Carolina, where 20,000 African American marines received basic training between 1942 and 1949. Prior to 1942, African Americans were not recruited into the U.S. Marine Corps. Watson was a distinguished veteran committed to goodwill and a spirited member of the community. (HPRF.)

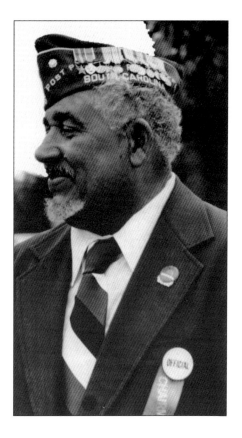

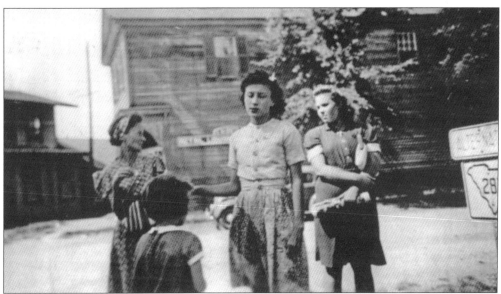

From left to right, Rose Mary Carey (foreground), Mrs. Marie Carey, Yvonne Carey, and Louise Sauls wait outside Carpenter's Hall to stand watch for enemy planes in the crow's nest during World War II in 1942. The Metcalf Store and the Port Royal train station are seen in the background. (HPRF.)

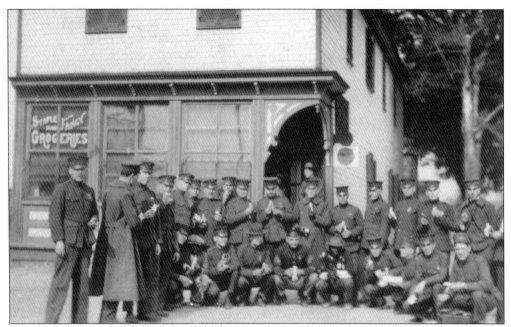

At the completion of boot camp, each battalion of new U.S. Marines was bussed back to Port Royal. It was their last chance to enjoy civilian life together before they caught trains to go home or to go to their next station of duty. The Marines shopped in the stores and bought from local teenage peddlers for last-minute items. This photograph was taken in front of the Appleton Building, known to many as the Metcalf Store. (Catherine Humbert Mascaro Brooks.)

The Marines said their good-byes at the Port Royal train station and were sent to fight in amphibious operations and air and land assaults in efforts to stop the Japanese advance through the Pacific Islands. Areas of conflict included Corregidor, Guadalcanal, the central Solomons, Iwo Jima, and Guam. By war's end, there were 485,000 Marines in six active divisions. (HPRF.)

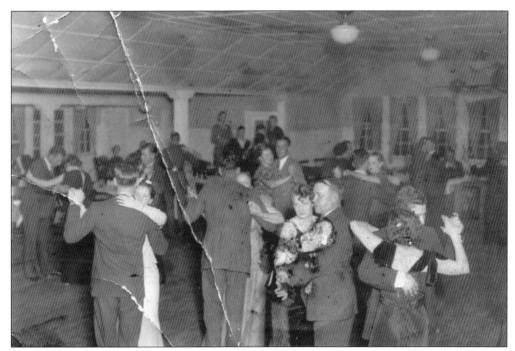

Vireen and Frank Tyree dance at the original Non-Commissioned Officer's (NCO) Club on Parris Island. Mr. Tyree was the first president of the NCO Club. Dances were often held for officers and their wives. The Tyrees' favorite dance was the three-quarter waltz. (Martha Ann Tyree Moussatos.)

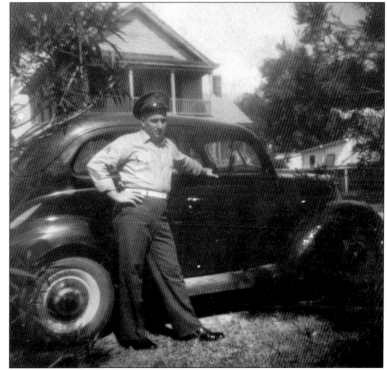

Al Mascaro Sr. stands in front of his 1937 Ford parked outside the Humberts' house on Eighth Street. Al began courting Catherine, the only daughter of Florrie and Wheeler Humbert, in 1946. They married in 1948, remained in Port Royal, and later had two children, Kathleen and Al Jr. (Catherine Humbert Mascaro Brooks.)

Shortly after Joe Shynkarek was assigned to Parris Island, he met Erma Sauls, a widow with six children under the age of 12. He married Erma, and they had two more daughters. He is pictured here with the older of the two, Lottie Shynkarek (Phinney). Mr. Shynkarek retired as a master sergeant in the U.S. Marine Corps after 30 years of service to our country. (Lottie Shynkarek Phinney.)

Margaret Geraldine "Jerry" Sample (Stocks), left, and Martha Ann Tyree (Moussatos), right, were born 16 days apart at the Naval Hospital on Parris Island. They were destined to be friends, since their mothers took walks together while pregnant. This picture was taken at a photograph shop on Parris Island when they were six years old. (Martha Ann Tyree Moussatos.)

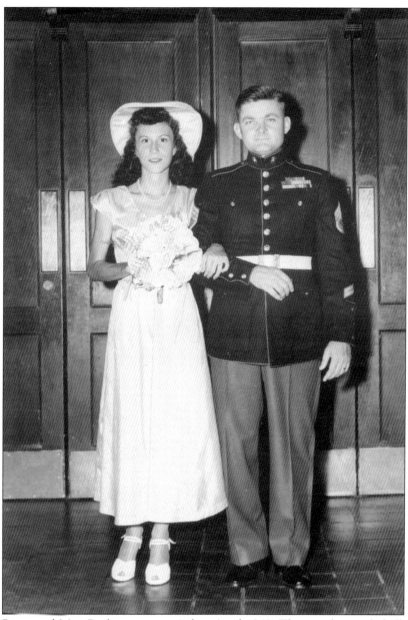

Yvonne Carey and Max Butler were married in April 1948. The couple traveled all over the country with the U.S. Marine Corps. In addition to World War II, Mr. Butler served in Korea and Vietnam. In 1962, they bought their first home on Smilax Avenue in Port Royal. Mr. Butler served his last tour of duty on Parris Island and became sergeant major of the 1st Battalion. He retired in 1970 after 30 years in the U.S. Marine Corps. Mrs. Butler wrote a biography entitled *My Life in a Nut Shell*, in which she describes Port Royal's love affair with Parris Island. She wrote, "The Marine Corps was good to the Town of Port Royal and also to the young girls of the town. We found some very good husbands in the Corps. I have had mine going on 50 years this next April. Many of these boys never went home; they had found a new home in Port Royal." Yvonne and Max had two children, Carey Maxwell Butler and Maria Estelle "Penny" Butler (Elias). (The family of Yvonne Carey Butler.)

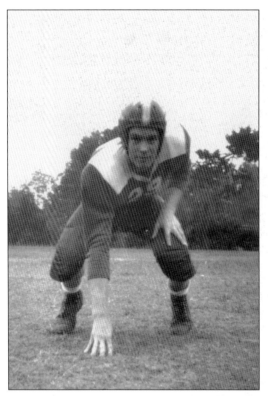

Bobby Chaplin, a star football player for Beaufort High School, poses in ready position his senior year. After he graduated in 1950, Chaplin began to think about a career, as all graduates do. Bobby (below, left) and his friend Bill Backus enlisted in the U.S. Marine Corps and headed to boot camp after signing up with a recruiter (center). The day after Bobby enlisted, he received a letter from Clemson University offering an opportunity to play for the school's legendary coach, Frank Howard. Just one year prior, Howard's Tigers won the Gator Bowl after a 10-0 season. Chaplin didn't play football for the Tigers, but he served our country in the Korean War. Chaplin was honorably discharged as a sergeant in 1954. After his career with the Marines, Bobby started a commercial fishing business and still shrimps today with his son, Gregory. (Bobby and Martha Chaplin.)

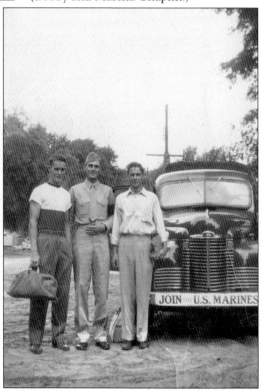

From center to right, Merle Rahn (Horton), an unidentified woman, and Virginia "Diddy" Vaigneur (Skinner) accept pins at a presentation that awarded civil service employees on Parris Island. However, the girls had to give the pins back after the ceremony. The awards were given for presentation purposes only, perhaps to save a dollar. In any case, there was a great need for civilian labor on Parris Island, and the government appreciated the women's work. (Faye and Ned Rahn.)

Jean Searson and James Lemuel Ritter were married at the Port Royal Union Church on January 22, 1950. Pictured here with the newlyweds at the Gold Eagle Tavern in Beaufort are, from left to right, Lewis Emeal Ritter, Jesse Lee Harter, Cecil Murray Tuten Jr., Elizabeth Searson King, and Margaret Smoak Searson. The Ritters met on Parris Island; Jean was a civil service employee in the Laundry, where Lemuel was the operations manager. (Ann Ritter Holmes.)

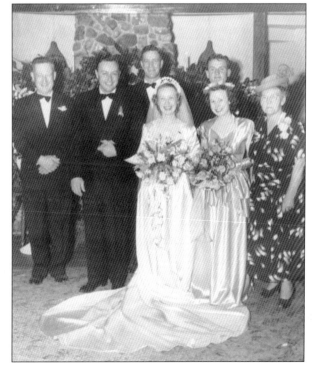

Saxby Chaplin was quartermaster sergeant in the U.S. Marine Corps during World War I and retired as a machinist on Parris Island. Marguerite Chaplin was an artist who used objects from nature, such as flora and shells, in her creations. They had six children: Ruth (Shuman) (Hejduk), William "Bill," Saxby "Jack" Jr., Marguerite "Teter" (Ramos), Robert "Bobby," and Charles "Charlie" Chaplin. (Bobby and Martha Chaplin.)

Bonnie and Harvey Tedder stand with their son, Zach, at the foot of the old Battery Creek swing bridge the day it was opened to traffic in August 1939. Tedder was head of the paint shop on Parris Island. Like all other military and civilian personnel, Tedder took a ferry from Port Royal to the recruit depot prior to the construction of the bridge. (Zach Tedder.)

Allen Davis came to Parris Island in 1941 as a naval medical technician. Mr. Davis took chest x-rays of recruits. If an abnormality was detected, the x-rays were sent to the Public Health Department on Boundry Street, where Katherine Butler, a Seabrook native, was a file clerk. They married in 1943 but didn't move to Port Royal until 1960. The Davises were very active in Port Royal Methodist Church, where Mr. Davis served as a youth director and finance chairman. (Allen Davis.)

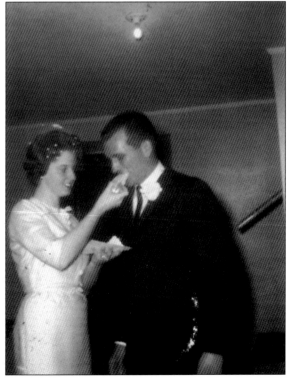

Ned and Faye Rahn were married in March 1963. Ned began work at the Marine Corps Air Station Fire Department in 1966 after four years with the U.S. Air Force. He became fire chief in 1980 and retired in 1990. Faye retired from civil service on Parris Island in 1999. They now operate a wholesale/retail nursery from their backyard on Smilax Avenue, offering a unique assortment of plants and a wide selection of citrus trees. (Faye and Ned Rahn.)

The State Ports Authority's involvement with Port Royal officially began in 1942, when it specifically mandated the development of the Beaufort–Port Royal Harbor as one of the state's three ports. Congressional appropriation passed and dredging began in 1956. State senator E. B. Rodgers, left, chaired a committee to negotiate with the C&WC Railroad for their terminal site. After acquiring the property, the SPA awarded the contract to build a 500-foot marginal concrete wharf with a 40-foot apron and 64,000 square feet of transit shed space. (Margaret Tedder Rodgers.)

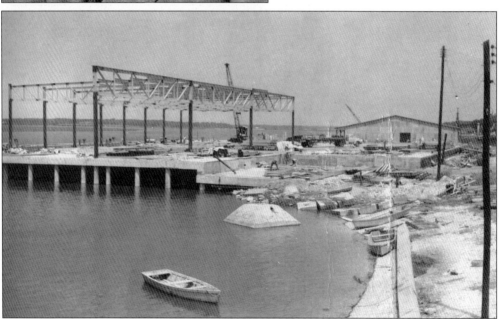

The U.S. Army Corps of Engineers' plan for dredging called for a channel 27 feet deep and 500 feet wide from the ocean across the bar to Port Royal Sound for 13 miles, then 24 feet deep and 300 feet wide in the Beaufort River and Battery Creek for 7.5 miles, leading to a 27-foot-deep and 600-foot-wide turning basin opposite the C&WC wharf. Construction of Pier 21 began in 1957. Edward M. Rodgers was later named pier superintendent. (HPRF.)

The Port of Port Royal was to be dedicated in September 1958, but Hurricane Helene postponed the ceremonies until October 4, 1958. The *Georg Russ* was the first commercial ship to tie up to Pier 21, two days before the rescheduled dedication. It was a 2,600-gross-ton West German vessel with an import of 300,000 board feet of cativo, a quality hardwood from Barraquillo, Colombia. (HPRF.)

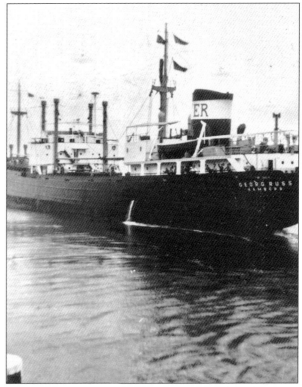

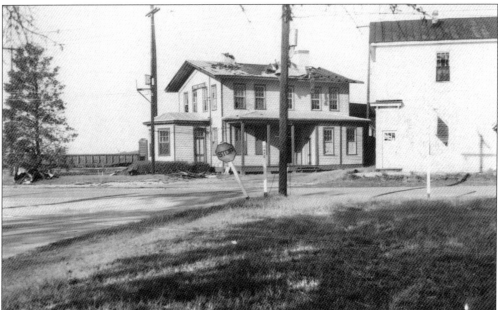

In 1959, Hurricane Gracie blew through Beaufort County, packing winds of 120 miles per hour. The Port Royal railroad station suffered extensive roof damage. Unfortunately the attractive building was torn down. Port Royal lost one of its most charming and historic structures. Hurricane Gracie was the last major hurricane to strike South Carolina before Hurricane Hugo hit 30 years later. (HPRF.)

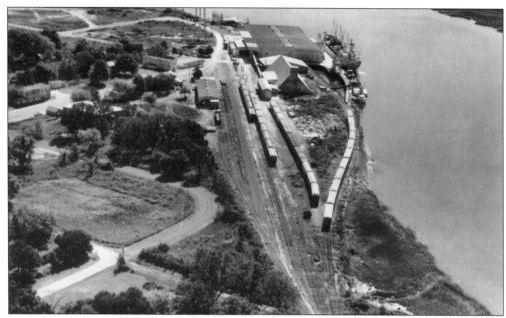

In 1960, the SPA announced that a new firm, the Port Royal Shipping Company, would handle the loading and discharge of cargo at the new port, naming E. B. Rodgers as its president, James Waddell Sr. as its vice president, and G. G. Dowling as secretary. With little cargo moving in 1963, the SPA leased half of the transit shed to Home Builders Corporation and in 1968 leased all of Pier 21 to the Port Royal Clay Company for the export of kaolin clay. (HPRF.)

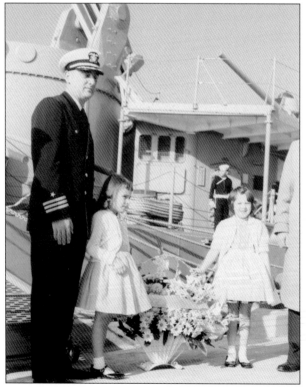

The USS Berkeley visited the Port of Port Royal in February 1963. The children from Port Royal Elementary School were invited aboard to tour the ship. Presenting flowers to the ship's commander are second-graders Kathleen Mascaro (Knisley) at left and Ann Ritter (Holmes) at right, who recalled feeling the beat of the Parris Island Marine Corps Band in her chest and stomach as she walked past the music to present the flowers. (Ann Ritter Holmes.)

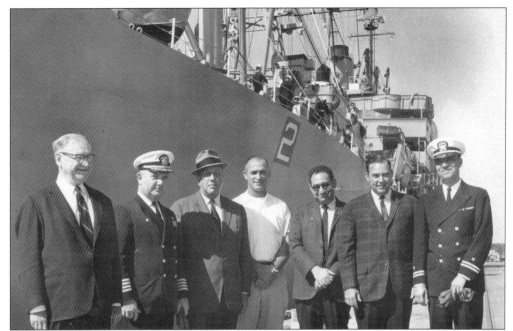

Other local dignitaries toured the USS *Berkeley* (DDG-15) when it came to port. Pictured from left to right are Bill Firth, the captain, Leroy Keyserling, Ed Rodgers, Ben Fox, Willie Scheper III, and the executive officer. The USS *Berkeley* was named in honor of Maj. Gen. Randolph C. Berkeley, a Medal of Honor recipient who commanded the Marine barracks at Parris Island and later resided in Beaufort and Port Royal. (Bill Scheper.)

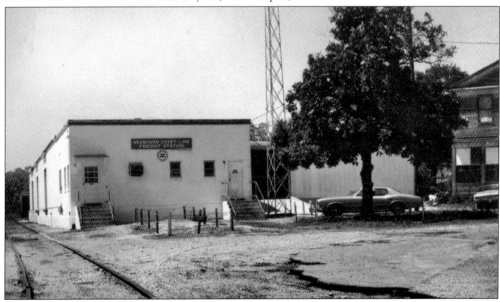

A major problem occurred in 1984, when the Seaboard Line System, Inc., successor to the C&WC Railroad, filed for permission to abandon the 25-mile spur between Yemassee and Port Royal. The line was crucial to the existence of the Port of Port Royal, since all of the port's cargo was moved by rail. The SPA made several attempts to find an operator for the line but finally purchased it for $550,000. (HPRF.)

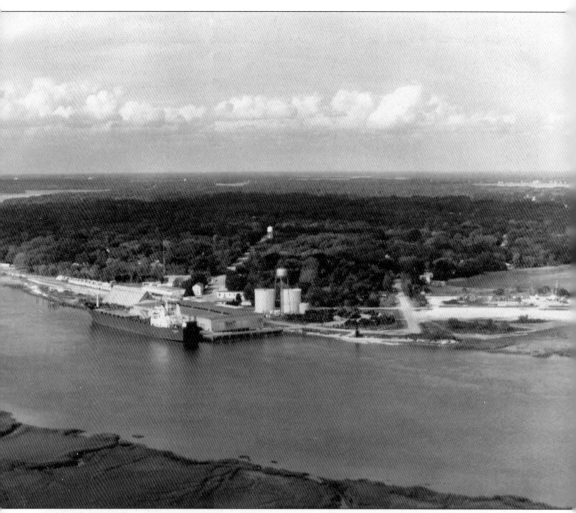

In 1984, the Port of Port Royal, Inc., began operations of the terminal. The firm, owned by Pete Cotter, invested in clay holding tanks and forklift equipment after it signed a contract with Repap Enterprises to import and export through Port Royal on a regular basis. Soon vessels were calling every three weeks. In 1987, the Town of Port Royal and the SPA announced a master plan for the development of Port Royal's waterfront. The plan called for the SPA to provide the town public waterfront access that included a park, a site for a boardwalk and viewing area, and a beach recreation area. In return, the town was to give the SPA a portion of four streets to provide a consolidated property line and area for the port to add another warehouse and floating dock. The SPA paid $600,000 for 55 acres from the Hood-Dowling Partnership for the dredge disposal area and public access. The Town of Port Royal built a boardwalk and observation tower with funds collected from the SPA, the South Carolina Coastal Council, the South Carolina Budget and Control fund, the National Park Service, and the Port of Port Royal, Inc. (HPRF.)

In 1995, the SPA took over operations of Pier 21 and hired Tony Pesavento as its terminal manager. The *Marine Confidence* was the first vessel called to port. It imported pig iron from the Middle East that was loaded onto rail cars and sent to a company in Georgia that used the commodity for making sprinkler heads in buildings to combat fires. (SPA.)

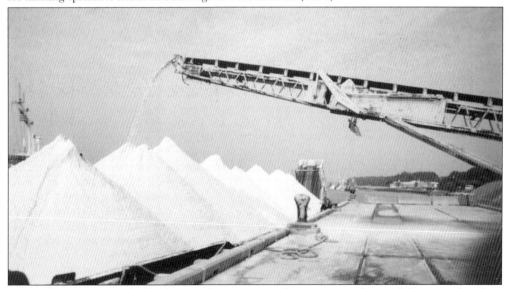

It was always more profitable for vessels to arrive with one commodity and depart with others produced in the United States. Such trade items that moved through the port included liquid fertilizer, feldspar, mica flakes, kaolin clay, paper products, and bananas. In this photograph, sand was loaded on a ship headed for the Bahamas. The developers of a golf course insisted on having the same sand as that found at Augusta National, which actually came from Spruce Pine, North Carolina. (SPA.)

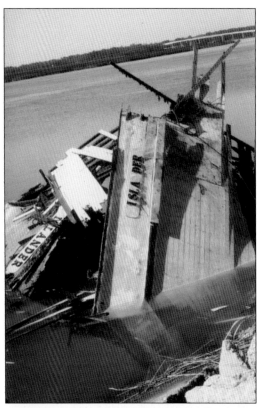

At one point, a shrimp boat sank at the Port Royal docks. The Coast Guard attempted to mark the wreckage, but they were never able to find it. Several years later, turbulence from a ship brought the shrimp boat out of the water, and the ship hit it. The Army Corps of Engineers was responsible for the recovery operation to remove the *Islander* from the water. (SPA.)

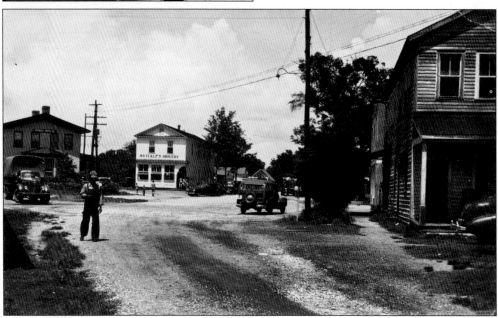

On September 21, 2004, Gov. Mark Sanford signed legislation to close the port and sell the valuable waterfront to developers by December 2006, putting the property back on the town's tax rolls as it was when this photograph was taken in the early 1940s. (Kent Bishop and Toni Metcalf Goodwin.)

Three

Shrimpin', Crabbin', and Fishin'

Before Charles Vecchio came to Beaufort, any shrimping in Beaufort waters had been in the creeks and rivers, but not on the deep sea for larger shrimp and not for commercial sales. Known as the "daddy" of the shrimp industry, Vecchio owned 22 boats in 1934. He shipped 125-pound barrels of shrimp packed down with ice to eastern and northern markets. Local fishermen began to see the potential of commercial sales and invested in boats. In August 1934, a total of 52 shrimp boats were reported in Charleston County waters, 11 in Georgetown County, and 66 in Beaufort County. There were setbacks, however. The location of docks were isolated and scattered; there were limited storage facilities; pollution control was costly; and shrimpers lacked accessibility to major markets. In any case, the industry, made of local and out-of-state boats, was important to Port Royal's economy. In 1937, Blue Channel Corporation opened, specializing in the processing and canning of Atlantic blue crab meat marketed nationally under the Harris Crabmeat label. In 1948, the business was described to be "susceptible to indefinite growth," but after the company sold to Borden's in the late 1980s, the crab factory soon closed its doors. Commercial canners of crabmeat and oysters went overseas, where labor was crushingly cheaper. The shrimping industry continues to survive, but due to a number of external factors, it has seen a steady decline in recent years. A major campaign to promote purchase of locally caught shrimp was initiated by the South Carolina Shrimpers' Association to resuscitate the waning industry. The industry was the town's salvation in earlier years; now, in its most crucial era, the shrimp industry is asking the town and its residents to reciprocate. The Town of Port Royal is currently brainstorming ways to recognize commercial fisheries, namely shrimping and crabbing, as part of the town's unique heritage.

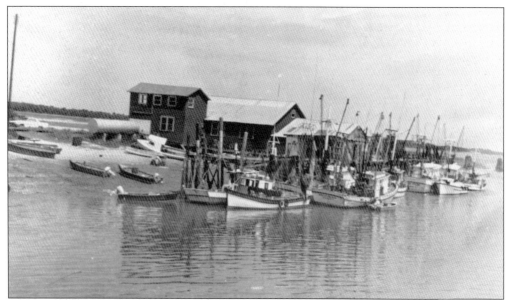

Charles Vecchio owned several shrimp boats that docked in Port Royal. He was the first to bring commercial shrimping to the area. Between Vecchio's fleet and four others, 66 shrimp boats were reported in Beaufort County in 1934. Only five boats were local. They operated off the barrier islands, packed the shrimp here at the wharf in Port Royal, and loaded the iced-down barrels on the nearby railroad cars. It was a successful operation that sent fresh shrimp to national markets. (HPRF.)

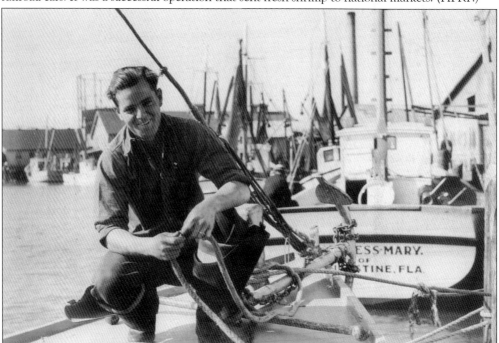

Taken in April 1939, this photograph shows George Randall, captain of the *Flying Cloud*, smiling on the bow of the fishing boat owned by A. A. Fagen of St. Augustine, Florida. The vessel was powered by a Caterpillar marine diesel engine. Randall insisted that Caterpillar diesels were tops, whether ashore or afloat. (HPRF.)

Charlie Wilson was born in Thunderbolt, Georgia, in 1909. He started shrimping in the 1920s, traveling to Mexico, the Yucatan, Mississippi, Georgia, and Florida. In 1929, he came to Port Royal on a shrimp boat and met Alice Jackson, who later became his wife of over 75 years. He is pictured at his house on Fifteenth Street mending a net, a trade he learned at an early age while shrimping. He used to make nets for $5 to $10 per week. (Alice Wilson.)

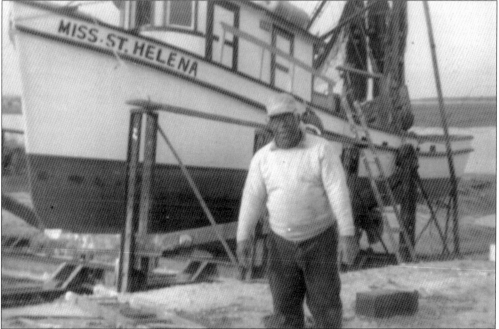

Charlie Wilson bought a shrimp boat in the 1940s and became the first African American shrimp boat captain in Beaufort County to own his own vessel. The boat was the *Miss St. Helena*. He later purchased the *Miss Christy*. Before the invention of navigational aids, many fishermen relied on Mr. Wilson's knowledge of local waters, especially those off Bay Point, known as "the Hump." (Alice Wilson.)

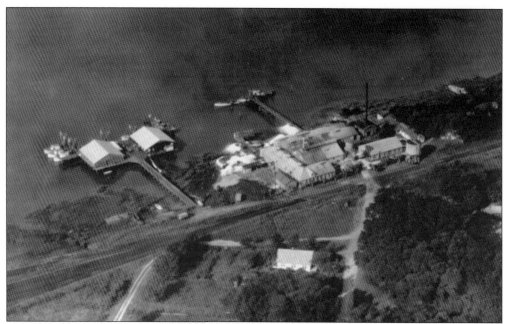

Blue Channel Corporation, owned and operated by Sterling Harris, was located at the west end of Eleventh and Twelfth Streets. The crab factory opened in 1937, a year after Mr. Harris left the Chesapeake Bay area to explore the coast for new crabbing grounds. With $500, he rented a shed, put in a vacuum apparatus, and started business. That first year, he shipped out a meager 500 pounds, but in 12 years, 300,000 pounds of the canned meat was shipped annually. (HPRF and David Bogan.)

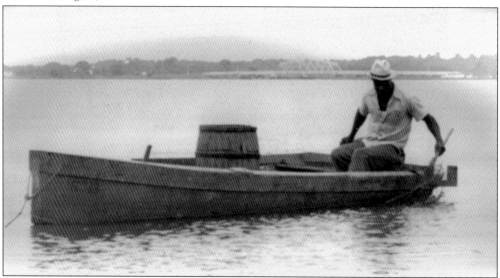

The primitive though professional style of crabbing consisted of a bateau made of swamp cypress planking and caulked with spare cloth, oars made of peeled saplings and flat slabs of wood, and a net made of chinaberry fork and chicken wire. Crabbers anchored one end of a trotline with loops every two-and-a-half feet tied with bait. The crabber slowly lifted the loaded line and dipped the net under the crabs just as the bait came into view, yielding about 30 "blue flippers" per minute. (HPRF and David Bogan.)

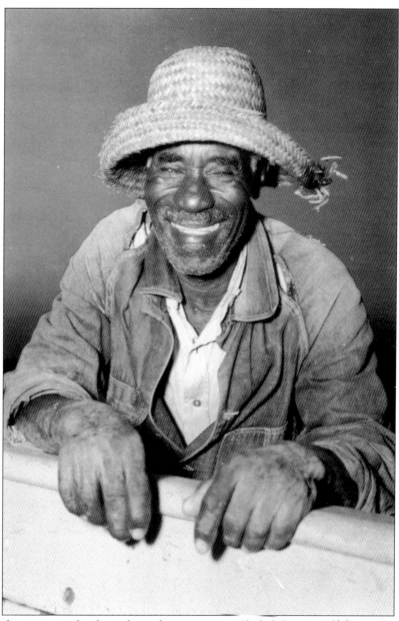

The capital investment for the independent operator included the cost of labor and material to build the boat, which averaged $25; a license that cost $1.50; and a $5–$6 trotline. Oil drums were free from Blue Channel. A fully equipped crabber received an immediate return on his investment, as the corporation weighed and paid on the drumhead. Joseph Riley was considered a professional in his trade. As an independent crabber, he made $5 to $10 a day, and the only daily expense incurred was bait. "Bacon rin' " was a constant 10¢ a pound, but stingray and bullnose varied between 3¢ and 8¢ a pound. Blue Channel sold the bait to the crabbers, but it was a not-for-profit transaction. Crabbers liked the bacon rin', because it lasted longer. Stingray was just as popular though, and cheaper. Many crabbers had a philosophy that if a crab was hungry enough, it would eat anything. More than likely though, the catch was determined by natural variables like horde movement, wind, weather, and tide. (Stan Waskiewicz.)

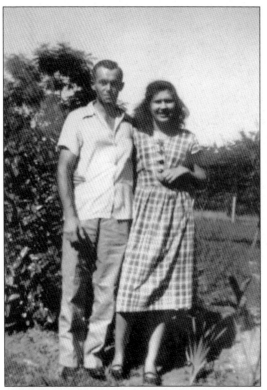

Blue Channel had a collecting fleet of five ex-army surplus tugboats, each working a territory and collecting from a fleet of 200 local crabbers. William "Cotton" Vaigneur worked on one of the "crab haulers" as a buyer off Daufuskie Island. A crane would swing the oil drum full of crabs onboard and place it on a scale, weighing the day's catch. Crabbers were paid by the pound. Pictured with Cotton is his wife, Mickey Rahn Vaigneur. (Faye and Ned Rahn.)

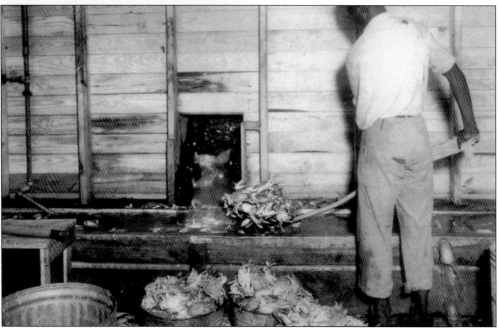

Every evening, oil drums full of crabs were loaded on a dolly that was pushed into the factory. The live crabs were poured from the drums into a steam vat for approximately eight minutes. In this picture, a factory worker shovels the steamed crabs down a chute to a conveyor belt that moves the crabs through a cracking apparatus invented at Blue Channel. (HPRF and David Bogan.)

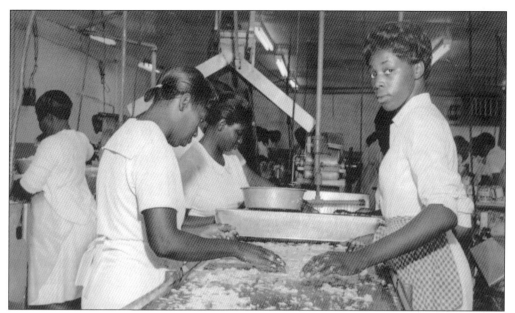

The crabmeat moved down the conveyor belt, where pickers, mostly African American women, removed the shells from the meat. Many of the women had brothers, fathers, or husbands who worked the trotlines. It was common for a family to bring in $75 a week. The best workers liked the night shift, for no other reason than an element of social prestige. There was always a waiting list for this particular shift, perhaps because it was Port Royal's hot spot for town gossip. There was one more inspection to ensure all shells were removed, and then the women below would place the crabmeat in cans to be sealed and labeled. (HPRF and David Bogan.)

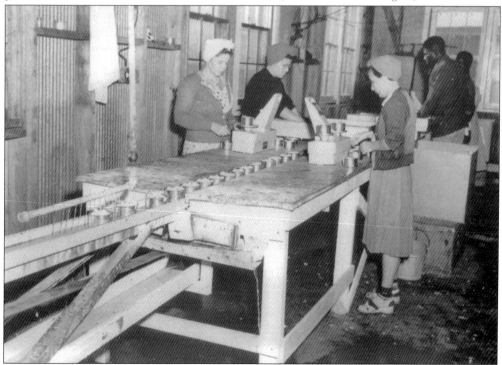

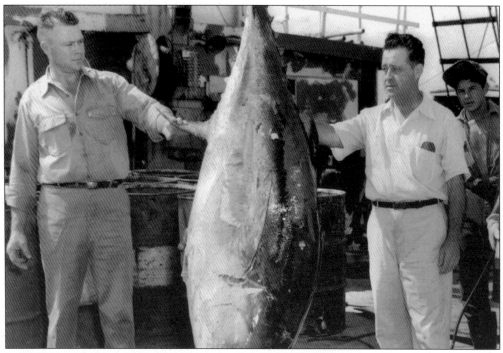

In 1951, Blue Channel started canning tuna. Boats fishing off the coasts of Peru, Panama, and the Galapagos could save time and money by unloading their catch at packing plants on the East Coast of the United States as opposed to California because it was half the distance. Sterling Harris realized the demand and started unloading and canning the yellowfin tuna at his factory. Harris (right) poses next to the large tuna with an unidentified man, perhaps a tuna-boat captain. (HPRF.)

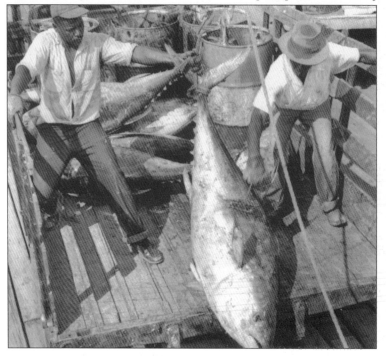

Blue Channel owned a building near the present site of the Beaufort Marine Corps Air Station that served as cold storage for the yellowfin tuna. The tuna, as seen in this picture, were loaded onto a truck and driven to Burton until the fish could be processed and canned. A tuna once fell out of the truck, providing Wally and Lottie Phinney a nice dinner for the evening. (HPRF.)

Stan Waskiewicz (seated, left) was president of Blue Channel for 34 years. He retired in 1985, one year before the company sold its operation to Borden's. Waskiewicz presided over the Port Royal factory and the company's plant in Belhaven, North Carolina. On any given day, both factories could bring in upwards of 100,000 pounds of crabmeat, profiting at a nickel per pound. Stan Waskiewicz is joined in this picture by his wife, Betty, and his two sons, Stan Jr. (standing, left) and William. (Stan Waskiewicz.)

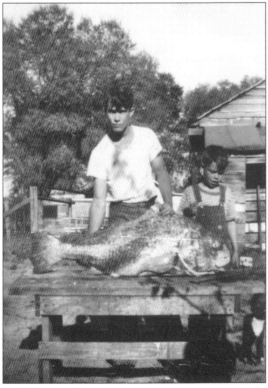

Bobby (left) and Charlie Chaplin pose with a large black drum almost 48 inches in length. The *Pogonias cromis* is a bottom dweller predominately found in inshore waters, but it is caught offshore as well. It is the largest member of the drum family, averaging 30 pounds. The black drum likes to feed on oysters, mussels, crabs, shrimp, and occasionally fish. (Bobby and Martha Chaplin.)

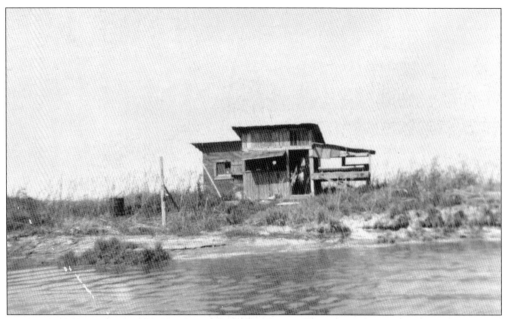

Known as the "River Rats' Camping Shack" on Bay Point, this classic camp was paradise for many young boys who grew up in Port Royal. They all had river rat names like Ace, Weasel, Crane, and Hunkie. They'd row their bateaux to the island with fishing tackle, lard, grits, cornmeal, and cooking utensils, and they ate what they caught from the river. It was heaven! (Lottie Shynkarek Phinney.)

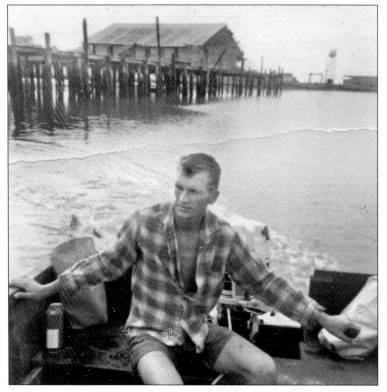

Ned Rahn steers his 50-horsepower Mercury on his 19-foot bateau made by his father, Hugh, in their backyard. Ned used the boat to crab with traps around Port Royal. Traps were a recent introduction to the area and were a more efficient method of crabbing than the trotline method. In the distance is the old shrimp dock. (Faye and Ned Rahn.)

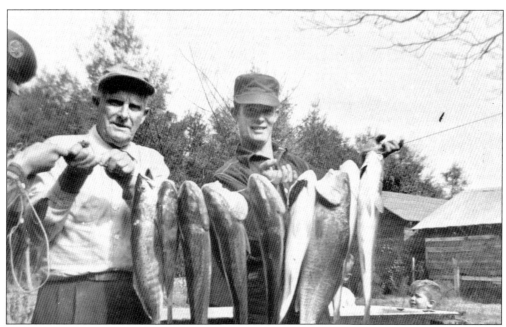

The red drum—or spottail bass, as it is often called—is by far the most admired inshore saltwater game fish in South Carolina. Saxby and Bobby Chaplin hold this stringer of reds at their home on Fifteenth Street well before South Carolina Department of Natural Resources (SCDNR) put strict regulations on size and catch limit. SCDNR now restricts the limit on red drums between 15 and 24 inches of total length per angler per day. (Bobby and Martha Chaplin.)

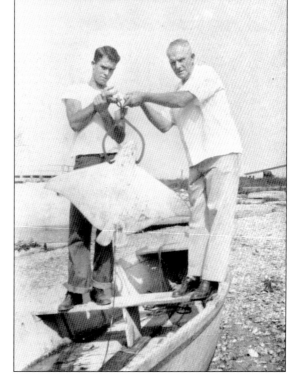

While fishing in Archer's Creek, Bill Chaplin was caught by surprise when this large manta ray or devil ray jumped in the small bateau. These rays vault above the water to attract mates or simply as a form of play; in either case, it's doubtful that Bill was the intended playmate. After bringing the ray ashore, Bill's brother, Bobby, and father, Saxby Chaplin, grasp the sea devil with a weighing tool.

Lewis Wright was born and raised in Augusta but summered on his grandfather's acreage, known today as Wright's Point. He later moved to Port Royal and worked as a civilian for the U.S. Air Force transporting VIPs like comedian Jack Benny and ice-skater Sonia Henie to USO events overseas during World War II. He also flew Henry Wallace, vice president in Franklin Roosevelt's administration. He later flew for TWA for 15 years and subsequently experimented with careers. He owned a dairy farm that eventually merged with Coburg; he sold artificial eyes for the American Optical Company in five states; and he dabbled in real estate and construction in the Beaufort area. Mr. Wright is also a distinguished horticulturist known regionally for his attractive camellia blooms. Below, Lewis Wright stands on the keel of a 52-foot vessel (the *Swamp Fox*) that he, George Feltwell, and George Randall built at Wright's Point. (Lewis Wright and HPRF.)

This photograph was taken at Wright's Point during the construction of the *Swamp Fox* in the early 1950s, when the old cottage was still standing. Charles Henry Sutler, left, helped with construction while Mr. Randall, right, designed the vessel and shaped her ribs. George Feltwell was the chief nail driver, and Lewis Wright assisted with the assembly. (Lewis Wright.)

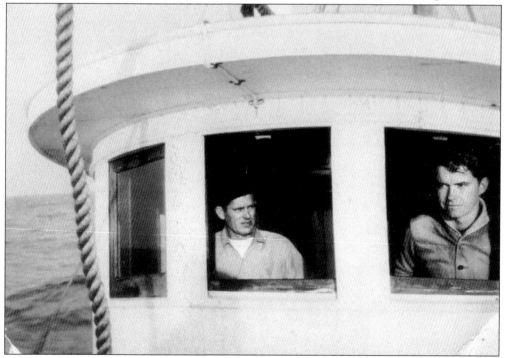

Fred Oga Vaigneur (left) and William "Tommy" Vaigneur stand in the pilothouse of an old shrimpboat in Port Royal. (Betty Vaigneur Abraham.)

When Wally Phinney Jr. was 13 years old, he made a surf rescue off Hunting Island to save the life of an 8-year-old who had stepped into a deep hole. Later he earned the Eagle Scout Badge, the highest achievement award given by the Boy Scouts of America. After graduating from Clemson, he began a 20-year career with the army. Since 1989, Wally has been operating fishing, cruising, and diving trips from the Port Royal Marina on the *Sea Wolf VI* or one of its predecessors. (Lottie Shynkarek Phinney.)

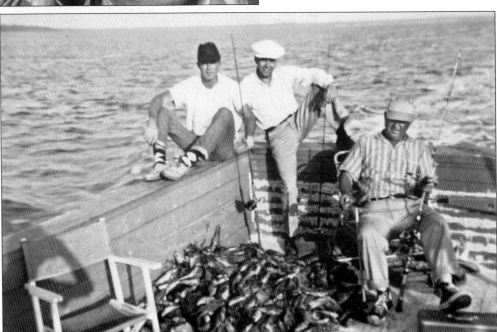

From left to right, James Marion "Sammy" Gray, his brother Richard Lee Gray, and father, Harold Bogan Gray Sr., take a break from fishing. The elder Gray and his wife, Evie Magahee Gray, had six other children who grew up in Port Royal: Harold Bogan Jr., George Donald, Barbara Ann (Lubkin), William John, Linda Elizabeth (Cross), and Roy Delano Gray. (Doris and Sammy Gray.)

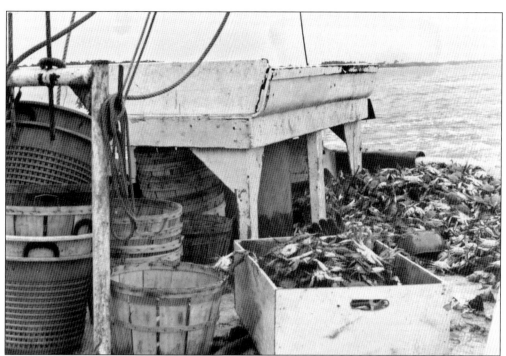

The blue crab—*Callinectes sapidus*—is highly edible at all stages of its existence. The mature female migrates to saltier waters after mating in the spring where she develops her sponge-like sac containing her eggs. The microscopic zoeae she lays become visible megalops and in rapid succession green crabs, peelers, busters, soft crabs, buckrams, and finally hard crabs of commerce. Since the crab's shell only stays soft for a mere 12 hours in each of its several sheddings, the soft-shell crab yields a higher dollar than the hard crab. Crabbers like Woody Collins, right, are aware that soft-shell crabs are abundant from April through July in the Lowcountry, due to the seasonal molting trends. Port Royal celebrates the delicacy with a Soft Shell Crab Festival in April. (Bobby and Martha Chaplin and Faye and Ned Rahn.)

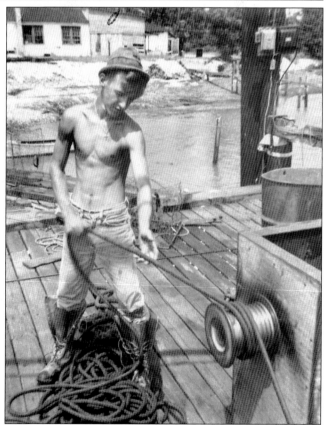

Lewis Wright built the Jes' Wright from top to bottom in two years by himself. He designed the boat on butcher paper from Koth's Grocery, constructed the hull with nothing larger than a two-by-four, and commercially fished the boat for 10 years. All the hardware was welded from salvaged stainless steel from the Charleston Shipyard with the exception of the rudders and rudderposts. The fish box was insulated with four inches of Styrofoam and, at capacity, could hold 3,000 pounds of fish and 2,000 pounds of ice. The decking was made with three-quarter-inch plywood and over 100 pounds of epoxy. The finished hull was towed to Marsh Harbor, where twin Ford diesels were installed. The boat cost $38,000 to build, less than half the cost of a purchased vessel of that size at that time. Bill Chaplin, below, was first mate of the Jes' Wright when it fished commercially for grouper, snapper, and mackerel. (Lewis Wright.)

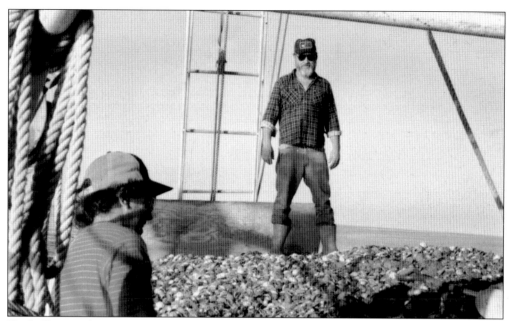

Keith, Tom, and Tommy Pender built the shrimp trawler *Sea Drifter* from an existing hull at the Port Royal docks. In addition to catching shrimp, the boat and crew also pursued scallops, another favorite delicacy of the sea. Historically scalloping has been a secondary fishery for shrimpers because of fluctuating populations, with the exception of eastern Florida. Increased coastal runoff due to the construction boom in the state threatened the scallop habitat. Recently a seven-year ban on recreational harvesting, a popular tourist activity, was lifted in Florida following a resurgence of the scallop population. In the photograph above, David Laban (left) and Tom Pender examine the day's catch. Below, Laban (left) and Keith Pender relax on the *Sea Drifter*. (Lewis Wright.)

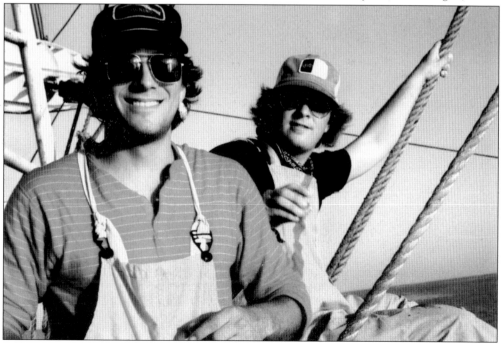

The last boat that George Randall built was the *Miss Latina*, constructed in his backyard at 1620 West Paris Avenue. It was lifted on a trailer, slowly towed through the streets of Port Royal, and launched at the Sands. Many people in town came to watch as Randall proudly inaugurated the shrimp trawler. (HPRF.)

Gregory (left) and Bobby Chaplin sort through the day's catch under the supervision of a nine-foot shark caught off the beach of Hilton Head in 1981. This shark was one of four they caught that day on the SS *Chaplin*. Three were trapped inside the net while one was apprehended outside of the net. (Bobby and Martha Chaplin.)

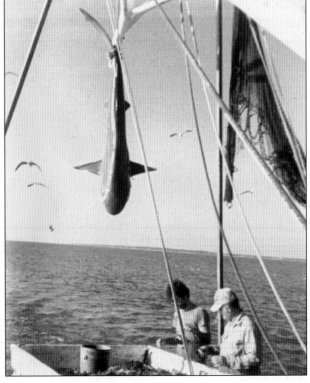

Jack Chaplin takes a break on the *Essie E. Green*, the second of six boats he owned. His first boat, nameless, was only 26 feet. Both vessels had wooden masts and were outfitted with only one net. Neither boat had a winch, and Chaplin used a lead line as a depth finder. Today they are outdated but still classic. (Jack and Sally Chaplin.)

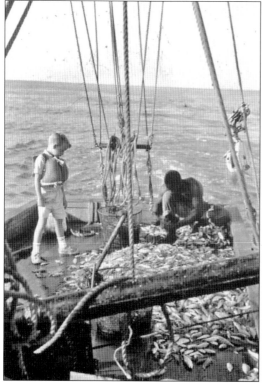

Dawes Cooke (left) helps Sam "Orrie" Williams Jr. sort through the day's catch. Dawes was Jack Chaplin's nephew, who was the same age as his oldest son, Johnny. The boys would go shrimping often with Mr. Chaplin. Orrie worked on Jack Chaplin's boats for 15 years. After the *Essie E. Green*, Jack owned the *Lady Mary*, the *Royal Flush*, the *Venture*, and the *Destiny*. (Jack and Sally Chaplin.)

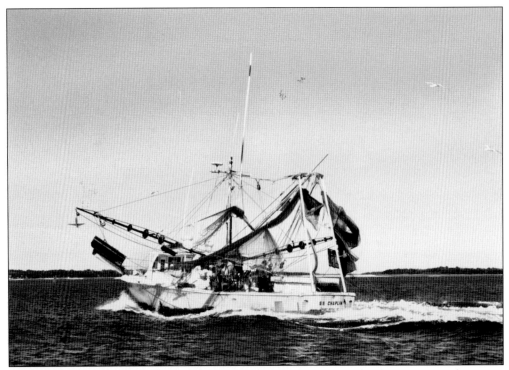

The SS *Chaplin*, named for Bobby Chaplin's father, Saxby Stowe Chaplin, cruises with its nets down, in the midst of catching shrimp.

Kerry Abraham stands aboard the *Miss Sherry*, a 60-foot shrimp trawler his father, Elias Abraham, bought and finished when the vessel's original builder, Henry Sutler, sold the hull in the midst of her construction. The *Miss Sherry* was named after Kerry Abraham's daughter and later sold to Jimmy Stanley. The boat, better known as the *Miss Jenny*, earned its fame during the 1994 filming of *Forrest Gump*. Stanley, who was at the helm during the scene when the trawler crashed into the Coosaw Bridge, sold the vessel to Planet Hollywood in 1997 for use as a future restaurant. (Betty Vaigneur Abraham.)

Four

A Revitalization

For several years, Port Royal sustained itself but minimally. Even in its economic collapse, there was camaraderie among its residents, who took great pride in their small town. The year 1974 marked the 100th anniversary of the town's incorporation. The town of Port Royal had a huge birthday party, complete with a blessing of the fleet, a parade, and a Lowcountry crab boil. Dignitaries also dedicated its new town hall. When the country celebrated its bicentennial, Port Royal wanted to be a part of it. The bicentennial was more than pageantry; it celebrated a national pride and spirit, belonging to all Americans in every state. Port Royal was officially recognized as an American Revolution Bicentennial Commission town. Its theme, Heritage '76, was a nationwide summons to reexamine our origins, our values, and the meaning of America—to recall our heritage. The calendar of events included the dedications of the Stephen C. Millett Mini-Park and Seafarer's Park. Many members of the bicentennial committee formed the Historic Port Royal Foundation shortly after the summer's festivities in an effort to preserve Port Royal's treasures. Through the 1980s and early 1990s, Port Royal tolerated nominal growth, but in 1997, the Town of Port Royal adopted the Traditional Town Overlay District. Subsequently the town experienced a revitalization. Property values increased, new construction entered the once-dilapidated village, and commercial interests flooded Paris Avenue. In 2004, Gov. Mark Sanford signed legislation to close the Port of Port Royal in an effort to further boost the town's economy. Residents and town and state officials are mutually working to develop a master plan for the valuable waterfront property, to be sold by December 2006. The town is in the midst of its most significant history.

Pictured at the dedication of town hall at 1402 Paris Avenue are, from left to right, James "Papa" Watson, Henry Robinson, John J. "Pie" Harter, Kate Kirkland, Mabel Brown, and Lowry Graham with spectators in the background. The facility was dedicated during the town's 100th anniversary of incorporation in 1974. Sen. James Waddell was the guest of honor. (HPRF.)

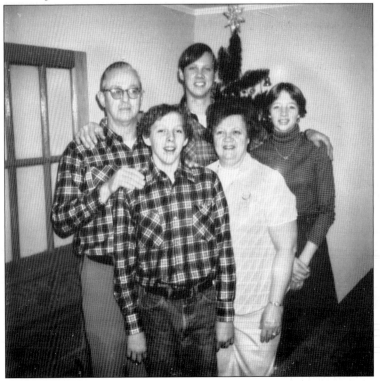

From left to right, Rex, Scott, Mike, Hazel (Sauls), and Paula Richard stand in front of the tree on Christmas Day 1976. The town of Port Royal celebrates Christmas with an annual Christmas tree lighting. Children are invited to tour Port Royal with their parents on one of the town's fire trucks. Additionally Santa Claus makes an appearance at the fire station to get lists from all of the good children in Port Royal. (Lottie Shynkarek Phinney.)

Arlene M. Bennett, cochairman of the Port Royal Bicentennial Committee, presents a plaque commemorating the town's official function in America's bicentennial celebration to Milton E. Mitler, deputy special assistant to Pres. Gerald Ford. The presentation was made in the Roosevelt Room of the White House. The plaque was displayed in the Great Hall of the Commerce Building. (HPRF.)

Martha Chaplin, Arlene Bennett, Agnes Picone, and Lillian Johnson supervise their children while riding on Port Royal's bicentennial committee's patriotic float during the parade. The parade started at Royal Oaks shopping center and headed south to the end of Paris Avenue. Many organizations participated in the parade, which was well represented with state and local officials. (HPRF; photograph by Ned Brown.)

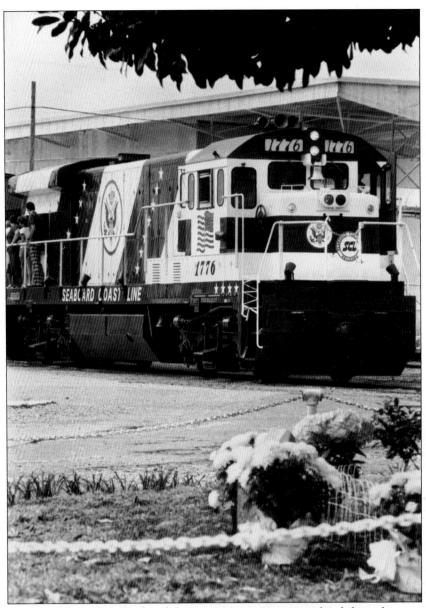

In 1970, Seaboard Coast Line Railroad Company's management realized that a locomotive was soon to be built that would bear the number 1776. The company saw a great opportunity to reaffirm its faith in the United States of America. The idea spawned the most celebrated locomotive ever to operate in the nation, according to railroad historians. The locomotive was dubbed *Spirit of '76*. General Electric Company built, painted, and decorated the 3,600-horsepower train at their plant in Erie, Pennsylvania. Unveiling ceremonies took place in Jacksonville, Florida, on July 13, 1971, at which time it was dedicated to the principles of patriotism and love of country. The inscription on the locomotive bell reads, "Liberty is more than heritage.... It is a fresh challenge and fresh conquest for each generation . . . a noble concept based on the dignity of man and the realization that man free is the greatest discovery of all ages." The *Spirit of '76* was on display in Port Royal prior to the dedication of the Stephen C. Millett Mini-Park. (HPRF; photograph by Ned Brown.)

John F. Morrall, the bicentennial historian, gives a tribute to Stephen Caldwell Millett at the dedication of the mini-park named in honor of the first president of the Port Royal Railroad Company. Martha Chaplin with Fox Jewelers engraved a plaque commemorating the park to read: "Millett Mini-Park—Dedicated to the memory of Stephen C. Millett, Builder and first President of the Port Royal Railroad and to all whose lives the Railroad has touched. PRBC—May 22, 1976." (HPRF; photograph by Ned Brown.)

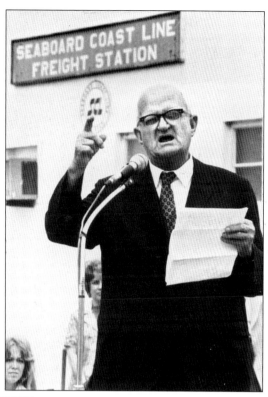

Emily Kent Bishop, chairperson of the historical and beautification committees, officially dedicates the Stephen C. Millett Mini-Park. Mrs. Bishop grew up in Ellenton, a town named after Ellen Dunbar, the daughter of a dear friend of Mr. Millett. Emily's father, Homer Kent, worked for the railroad in Ellenton and later moved to Port Royal to become the telegraph operator. (HPRF; photograph by Ned Brown.)

Emily Bishop (left) explains the itinerary of the dedication of Seafarer's Park to William Ballou, program coordinator for the South Carolina American Revolution Bicentennial (ARB) Commission, as David Bogan and Arlene Bennett, cochairs of Port Royal's bicentennial committee, look on. Ballou presented the ARB's official flag and certificate of recognition as a bicentennial community to the town of Port Royal. (HPRF; photograph by Ned Brown.)

Seafarer's Park was built to perpetuate the memories of Port Royal's past and present seafarers—captains, stevedores, merchant seamen, fishermen, and sailors. Many in the community helped with the creation of the park. Bobby Chaplin donated the anchor, and his wife, Martha, engraved the plaque. David Bogan cleaned and mounted the propeller that Tom Pender bestowed to the town. Others helped level the ground, lay the foundation for the marker, and move azaleas from the Tyree house to the park. (HPRF; photograph by Ned Brown.)

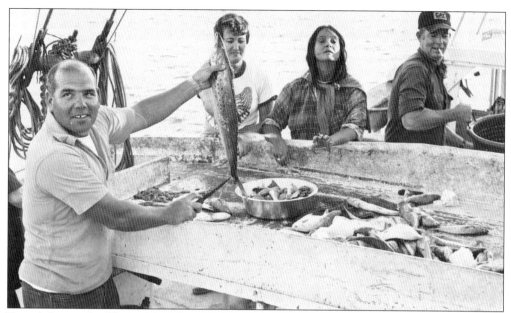

From left to right, Harvey Cawthorne, Martha Chaplin, Amy Compton, and Bobby Chaplin clean the catch aboard the SS *Chaplin* in preparation for the community seafood cookout given after the dedication of Seafarer's Park in the Port Royal Elementary playground. The Country Legend Band provided the music while the fish fried and the shrimp and crabs boiled. (HPRF; photograph by Ned Brown.)

An active member of the community, James "Itty Bitty" or "Papa" Watson served on Port Royal's bicentennial committee. Watson points George O'Kelley, a fellow Marine, in the right direction at an event during the celebration. In 1976, O'Kelley was running for the South Carolina House of Representatives seat that included Port Royal. He later became the Town of Port Royal's attorney. (HPRF; photograph by Ned Brown.)

A harbor tour was planned as part of the bicentennial celebration. The tour of historic forts was scheduled to depart from Port Royal aboard the U.S. Marine Corps' 65-foot boat, the *Pride*. Nell Ott, president of the VFW Women's Auxiliary in 1976, was in charge of placing flags at the forts so that passengers aboard the *Pride* could easily identify the sites. Unfortunately, due to last-minute insurance problems with the vessel, the tour was cancelled. (HPRF.)

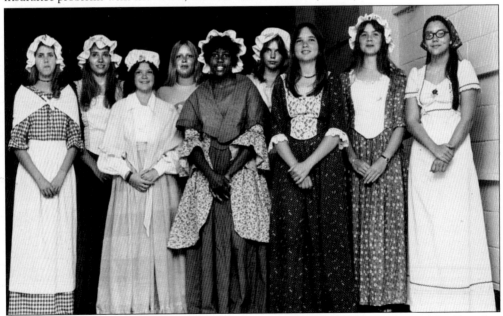

Junior hostesses for the Port Royal bicentennial festivities included members of the Beaufort County Senior Girl Scout Troop 463. As hostesses, the girls assisted committee members and supplied pamphlets and brochures to visitors. They are, from left to right, Gilen Meibaum, Carole Sanders, Susi Barker, Nanette Beatty, Donna Jacobs, Susan Sanders, Kathy Watts, Carol Albertson, and Marie Goodson. The troop advisor was Barbara Holbrook. (HPRF; photograph by Ned Brown.)

From left to right, Mayor Melvin Hector, Mayor Pro-Tem Henry Robinson, and Councilman David Bogan participate in the cake-decorating contest, part of the Festival USA celebration during the bicentennial week. The Port Royal officials took on the City of Beaufort officials in the sugarcoated challenge. (HPRF; photograph by Ned Brown.)

Stratton Demosthones proudly displays the plaque won by the City of Beaufort officials in the cake-decorating contest. The award reads, "Be it known to all persons that the City of Beaufort is hereby awarded this Golden Spatula of creativity and adeptness at smoothing over what he spreads." (HPRF; photograph by Ned Brown.)

Winners of the Port Royal Bicentennial Talent Show were Teresa Holbrook, Debbie Zook, Lori and Leilani Miller, Cheryl Carey, Kim Bogan, Robbie Patrick, Cheryl Allen, Wanda Felix, Judy Moultrie, Jacque Ficklin, Mary Anne Glover, Von Cole, Yvonne Cross, Gilen Meibaum, Scott Campbell, Valerie Cole, Michele Felix, Joyner Lights, and Diane Vaughn, all of whom are pictured here. The contest was held at Mossy Oaks Elementary School. (HPRF; photograph by Ned Brown.)

Take your partner and do-si-do. The Beaufort Squares were founded in 1963 with 23 couples. Active in the community, the group danced at nursing homes, festivals, and square-dance clubs around South Carolina. They also performed at Festival USA in the Royal Oaks shopping center parking lot during the bicentennial week.

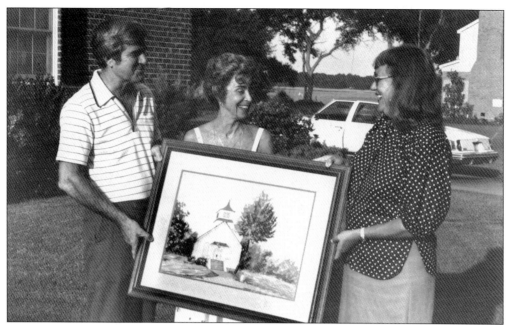

Richard and Joyce Gray accept a framed watercolor painting of the Port Royal Union Church from Martha Ann Tyree Moussatos. The Grays won a raffle organized by the Historic Port Royal Foundation that raised money for the restoration of the Jernigan-Long House, owned by the foundation at the time. The watercolor was the work of Gladys Folk of Williston, South Carolina. (HPRF.)

From left to right, Dahlia Rahn, Merle Rahn Horton, Bessie Vaigneur, and Mickey Rahn Vaigneur gather around the backyard for some good old-fashioned girl talk. (Faye and Ned Rahn.)

From left to right, Kent Bishop, Toni Metcalf (Goodwin), Dottie Morrall (foreground), Clyde Bishop, Emily Kent Bishop, Doris Kent Metcalf Morrall, and Johnny Morrall gather around the living room for a family photograph. (Kent Bishop and Toni Metcalf Goodwin.)

From left to right, Gilda Vaigneur (Huff), Kathy Raino (Pender), and Tracy Rahn (Pocta) enjoy making snowballs and tasting the frozen treats after a rare blizzard in February 1973. According to a USA Today weather log for the area, a total of 6.4 inches fell in Port Royal. (Faye and Ned Rahn.)

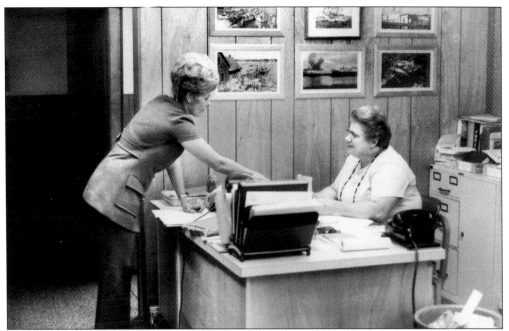

Al and Catherine Mascaro owned the Port Royal Oil Company, located where the Keyserling Cancer Center was built in 2006. They serviced home heating oil tanks before electric heat became standard. Catherine (left) and Helen Foster, friends since childhood, kept the books. Linda Pender Herring subsequently kept the books for 33 years. (Catherine Humbert Mascaro Brooks.)

Billy Keyserling was the state representative for Port Royal. He was also instrumental in creating a new urbanism in the village of Port Royal. He developed Charleston-style houses on a large tract west of Paris Avenue and south of Eleventh Street, making the neighborhood very friendly to pedestrians. (Town of Port Royal.)

This masonry building was constructed around 1838 for use as a customhouse. Strengthening rods were installed through the structure, leaving the outer washers and nuts exposed. These became known as "earthquake bolts" after the Charleston earthquake of 1886. The building housed the *Palmetto Post*, a bakery, a Masonic lodge, Sam's Place, and the Last Chance Saloon. (HPRF.)

In 2005, the Meridian Company, owned by Chuck Ferguson, renovated the old customhouse. The town was in the process of condemning the building before its current owners convinced the town council they could save it. The building was leaning out of its square shell. Ferguson removed all the parging (stucco) and began the process of repointing the entire building. As a result of infiltrating moisture, the old wooden headers had rotted. The Meridian Company fastened a new structural front to the existing building. Today Small City Café calls it home.

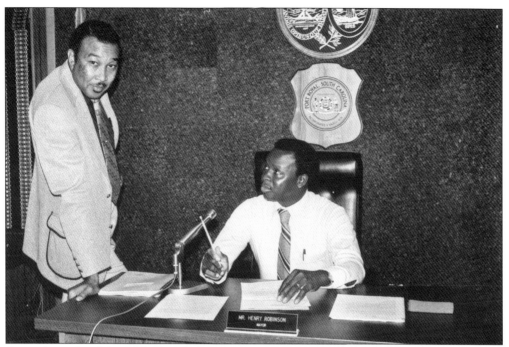

Councilman Sam Murray (left) and Mayor Henry Robinson (right) switched positions after Mayor Robinson stepped down from his post. He was later elected to fill a council seat while Sam Murray was elected mayor. (Town of Port Royal.)

The Town of Port Royal is in the midst of change. Recent annexations and height ordinances have sparked controversy, crowding council chambers. Open dialogue between town officials and the residents of Port Royal remains crucial to the development of the town.

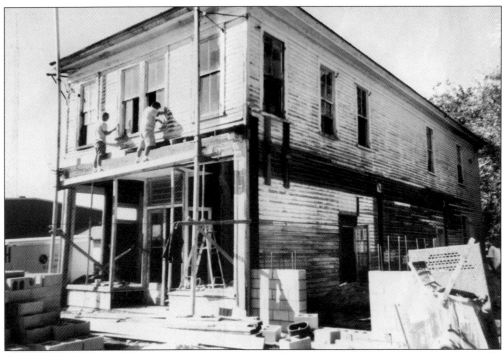

The Scheper Store once provided provisions to ships that docked in Port Royal Harbor and sold groceries, grain, and hay. A one-story structure attached to the east side served as a post office. The building fell into disrepair after the store closed in 1955. In 1979, Margaret Scheper Trask and Priscilla Aimar Trask reopened the building as a market and named it Papa's Store. In 2003, the building was renovated by Carol and Terry Poore and reopened as a home and garden store, called Lollygags. (Terry Poore and HPRF.)

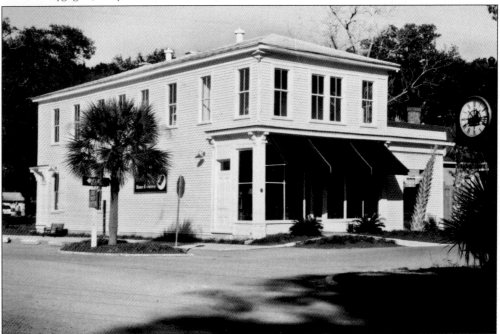

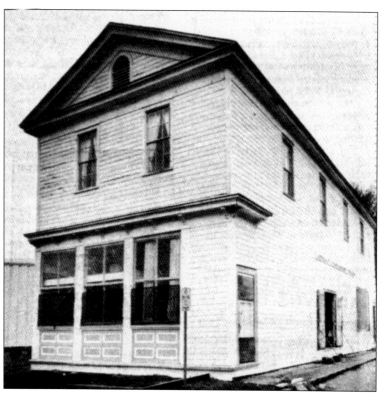

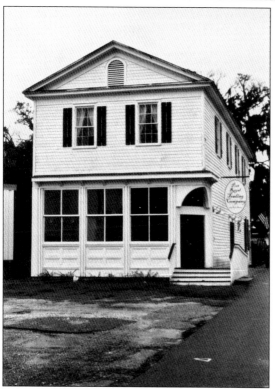

Doris Metcalf (Morall) ran Metcalf's Grocery until the mid-1950s, when it became a boardinghouse. In 1985, Mrs. Morall and her sister, Emily Kent Bishop, leased the building to Metcalf Lowcountry Theater, above, named in honor of Elmo Metcalf. The building, cleverly dubbed "the Met," later became home to Club Karate. Port Royal Trading Company, at left, now occupies the historic treasure. Today Lollygags and Port Royal Trading Company define the end of Paris Avenue. Major renovations saved the buildings from condemnation. After the sale of the port property, this area will be the last reflection of the town's past and a welcome point to the town's future. Efforts are being made by town officials to ensure that Paris Avenue will remain Port Royal's main shopping district. (Top HPRF.)

Of Pinky Jackson's six daughters, two are pictured here in front of the door casing at their childhood home on Twelfth Street, known as the "Ma Pink" house. Alice Jackson Wilson (left) was born in 1912, and her sister, Hadie Louise Jackson Snipe, was born two years prior on "the last street in Port Royal," as described by Mrs. Wilson. In 2006, Mrs. Wilson is known to be the oldest living resident born and raised in Port Royal. (Alice Wilson.)

The Russell K. Bell Bridge opened on Saturday, May 7, 1994. The span was named in honor of a Beaufort County deputy killed in the line of duty who was also a 25-year veteran of the U.S. Marine Corps. The new crossing replaced the aging steel swing span built in 1938. (Town of Port Royal.)

The Gullah Monument at the end of Eleventh Street was dedicated on May 26, 1995. Its plaque reads, "Dedicated to those who were taken from the Motherland. Know the teachings. Respect the elders. Keep the unity. Maintain the faith.—The Gullah Festival of South Carolina, Inc." In this photograph, Margaret Simmons visibly blesses the memorial. The Gullah Festival was founded in 1986 by Rosalie Pazant, Charlotte Pazant Brown, Lolita Pazant Harris, Reba Pazant Hunt, and Marlena McGhee. (Town of Port Royal.)

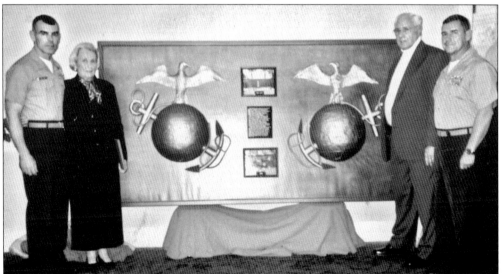

Col. R. W. Semmler, Catherine Humbert Brooks, Glen Brooks, and Brig. Gen. J. J. McMenamin stand around the eagle, globe, and anchor emblems that adorned the front gate of Parris Island from 1943 to 2001. Mrs. Brooks's father, Wheeler Humbert, handcrafted the emblems out of scrap metal. A Marine engineer discovered Mr. Humbert's art and recommended they be displayed at the front entrance. The emblems were transferred to the Officer's Club when security heightened after the events of September 11, 2001, and a new gate was constructed. (Catherine Humbert Mascaro Brooks.)

U.S. Congressman Joe Wilson's 2005 "Real Results" bus tour included a stop in Port Royal. After touring the Port Royal Dock Redevelopment by bus, the congressman and local officials posed for a group shot. They are, from left to right, South Carolina state representative Catherine Ceips, Port Royal mayor Sam Murray, Congressman Joe Wilson, Tony Pesavento, Yvonne Butler, Roxanne Wilson, Charlotte Gonzalez, Heather Simmons Jones, Van Willis, Ted Felder, Dean Moss, Vernon DeLoach, Joe Lee, Bob Bender, Libby Barnes, Terri Lee, Ann Marie Adams, and David Kell. (The family of Yvonne Carey Butler.)

Dave Murray, Port Royal's postmaster from 1993 to the present, was awarded South Carolina's Postmaster of the Year in 2006 from the South Carolina Chapter of the National Association of Postmasters, an award he shares with his twin brother, Jonathan. Murray began his career as a part-time clerk on Hilton Head Island and, after 36 years of service, plans to retire in 2008. (David Murray.)

Most members of the Pender family moved to Port Royal from Columbia. In this photograph from left to right are (seated) sisters Linda Pender Herring and Hazel Pender; (standing) brothers Tom, George Marion, Johnny, and Jim Pender. The familiar Pender Brothers (Johnny and Jim) started their plumbing, welding, heating, and air conditioning business in Shell Point in 1985. They moved in 1996 to their current location at 1851 Ribaut Road, where their sister Linda also operates a Penske truck rental business. (Hazel Pender.)

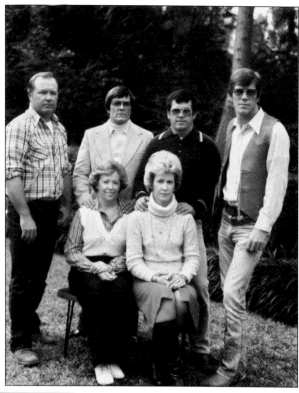

Tanya Payne (left) and Cynthia Smalls (right) have been working for the Town of Port Royal for 15 years and 28 years, respectively. They were awarded the Paul Harris Fellow Award from the Beaufort Rotary Club for their outstanding service to the community. (Town of Port Royal.)

Port Royal Elementary School's original deed stated that the town conveyed four lots to Beaufort County on which to locate a school with a provision that if the school ever ceased to exist, the property and building would revert back to the town. This reversion clause stopped the Beaufort County Board of Education from discontinuing the use of the building as a school after many years of trying. Today Port Royal Elementary has an enrollment of over 300 children. Pictured are students from Brantley Hodges and Juliana Smyth's first- and second-grade class: from left to right, (first row) Wyatt Kenninger, Janna Townsend, Dezire Jackson, Nicholas Elam, Haley Weber, Amber Gielarowski, Trey Dean, John-Ryan Goneke, Dylan Williams, Patrick Walker, Ethan Fackrell, Michael Lopatka, and Daniel Morning; (second row) Jaxon Spratling, Cole

Tyler, Grayson Rowell, Mariah Toy, Taylor Owen, Alexis Kelnhofer, Elizabeth Henderson, Andy Copeland, James Polk, Adrianna Tarver, Gio Aguilar, Dylan Palonis, Phoebe Capps, Grace Lubkin, and Emily Potter. In 1998, Kay Keeler, the school's principal, and a team of community members, district office personnel, teachers, and administrators developed the Renaissance Plan for Port Royal Elementary School, which incorporated multi-age groupings, continuous progress, arts infusion, thematic units, uniforms, and a total new philosophy of education. The school was a natural to move into the International Baccalaureate Primary Years Programme, which encourages students to be active learners, well-rounded individuals, and engaged world citizens. (Port Royal Elementary School.)

ACROSS AMERICA, PEOPLE ARE DISCOVERING SOMETHING WONDERFUL. THEIR HERITAGE.

Arcadia Publishing is the leading local history publisher in the United States. With more than 3,000 titles in print and hundreds of new titles released every year, Arcadia has extensive specialized experience chronicling the history of communities and celebrating America's hidden stories, bringing to life the people, places, and events from the past. To discover the history of other communities across the nation, please visit:

www.arcadiapublishing.com

Customized search tools allow you to find regional history books about the town where you grew up, the cities where your friends and family live, the town where your parents met, or even that retirement spot you've been dreaming about.